PHOTOGRAPHING THE DRAMA OF DAILY LIFE

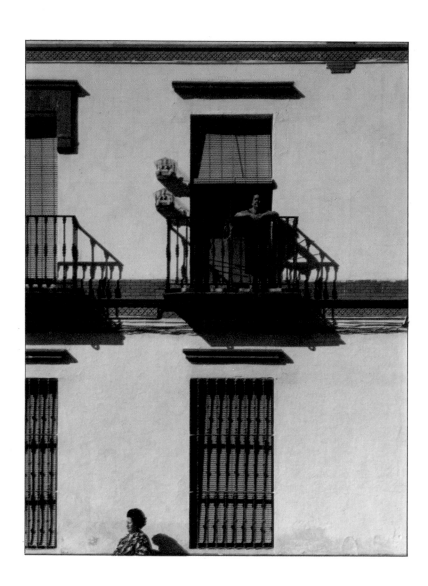

PHOTOGRAPHING THE DRAMA OF DAILY LIFE

Published by Time-Life Books in association with Kodak

PHOTOGRAPHING THE DRAMA OF DAILY LIFE

Created and designed by Mitchell Beazley International
in association with Kodak and TIME-LIFE BOOKS

Editor-in-Chief
Jack Tresidder

Series Editor
John Roberts

Art Editor
Mel Petersen

Editors
Louise Earwaker
Richard Platt
Carolyn Ryden

Designers
Marnie Searchwell
Lisa Tai

Assistant Designer
Stewart Moore

Picture Researchers
Veneta Bullen
Nicky Hughes

Editorial Assistant
Margaret Little

Production
Peter Phillips
Jean Rigby

Consultant Photographers
Julian Calder
John Garrett
Donald Honeyman

Coordinating Editors for Kodak
John Fish
Kenneth Oberg
Jacalyn Salitan

Consulting Editor for Time-Life Books
Thomas Dickey

Published in the United States
and Canada by TIME-LIFE BOOKS

President
Reginald K. Brack Jr.

Editor
George Constable

The KODAK Library of Creative Photography
© Kodak Limited. All rights reserved

Photographing the Drama of Daily Life
© Kodak Limited, Mitchell Beazley Publishers,
Salvat Editores, S.A., 1984

Library of Congress catalog card number 82-629-81
ISBN 0-86706-224-X
LSB 73 20L 09
ISBN 0-86706-226-6 (retail)

Contents

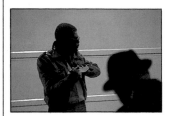
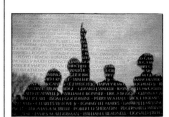
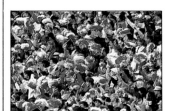

LIFE THROUGH THE LENS

A child looks out of a window, silhouetted against the soft daylight. The situation could hardly be more commonplace or the image more simple. Yet to look at the picture opposite is to be drawn into the compelling silence of the room in which the child stands. This poignant sense of being in direct touch with a passing moment of life lies at the heart of many photographs taken by masters such as Jacques-Henri Lartigue, Henri Cartier-Bresson and, here, Ernst Haas.

This book shows that the skills needed to photograph daily life in all its immediacy are accessible to anyone. Technically, the pictures on the following nine pages needed little beyond speed of camera handling. They range from news events to images of ordinary people, but all of them involve us in what is happening. To achieve this kind of spontaneity, candid photographers and photojournalists rely more on watchfulness than on complex equipment. There are simple ways, as this book describes, to improve your reaction time and your skill in taking unposed pictures without attracting too much attention. By practicing these and by developing an eye for story-telling images, you can record the drama of daily life in the subjects that surround you.

Old-fashioned curtains veil a figure at an open window, helping to create a sense of isolation and longing. To enhance the silhouette effect and the contrast between the musty room and the light outside, the photographer gave one stop less exposure than the camera's meter indicated.

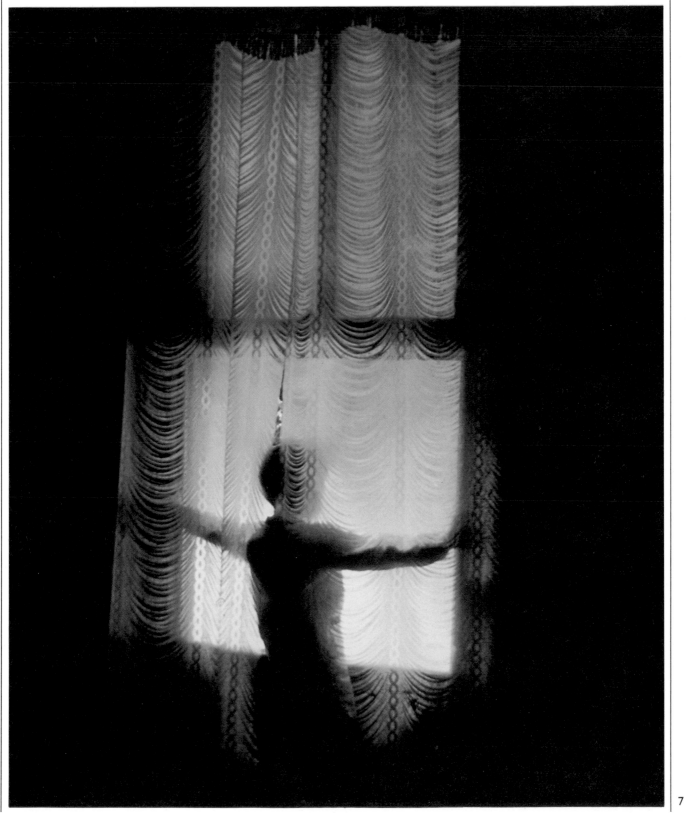

A burning building at dusk is recorded with a fast 85mm lens set at f/2 and 1/60 on ISO 200 film. This kind of dramatic incident needs only quick reactions and good camera technique.

Standard bearers at a parade in Tucson, Arizona, become a swirl of color as the camera pans them at a shutter speed of 1/8. The blur of movement helps to involve the viewer.

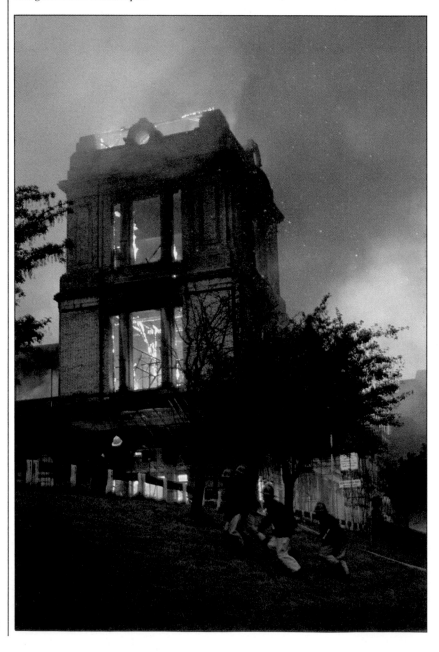

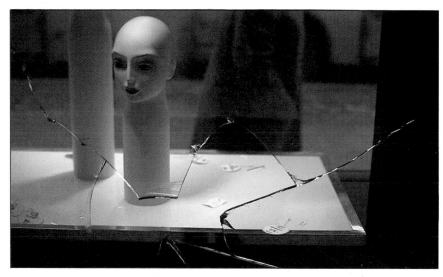

A broken window and an empty arcade display in West Berlin suggest the violence of the city streets. A small aperture kept both the mannequin head and the smashed glass in focus.

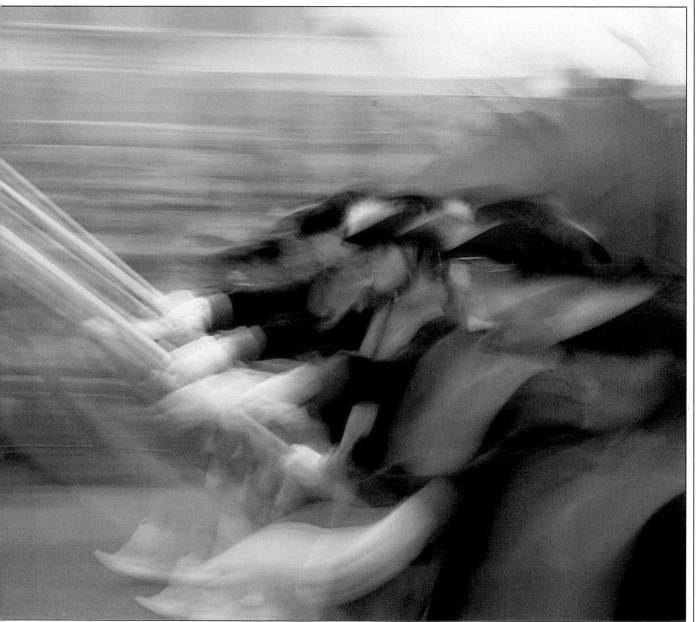

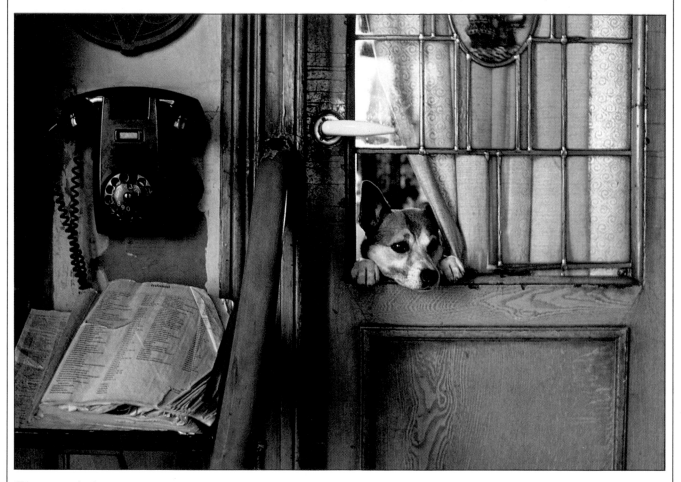

The owner's dog peeps *through an empty pane in a door at the back of an Amsterdam café. By being quick with a 100mm lens, the photographer has drawn our attention to the quiet humor of a simple slice of life, the worn phone book adding to the picture's realism.*

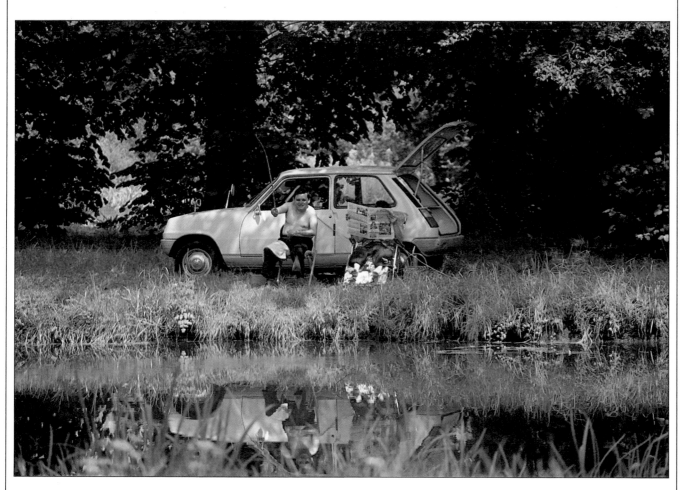

An inexpert fisherman
*attempts to retrieve his
snagged line from a weedy
river. The photographer
noticed the childlike glee
of the subject's efforts and
the contrasting indifference
of his companion, and framed
the scene with a 135mm lens
from the opposite bank.*

An out-of-season sun worshipper (right) coaxes the maximum warmth from the winter sun. The photographer sighted the man on the boardwalk at New York's Coney Island and took a quick picture, using a 35 mm lens to include the steel door that adds to the bizarre metallic quality of the image.

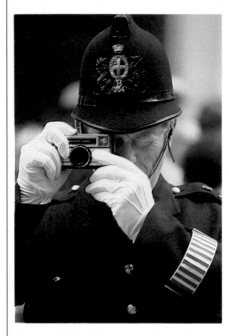

An unofficial photographer (above) makes the most of a privileged position at the Prince of Wales's wedding in London. Keeping an eye out for the off-beat incident, the photographer used a 180 mm lens to fill the frame with the subject from a position in the waiting crowd across the street.

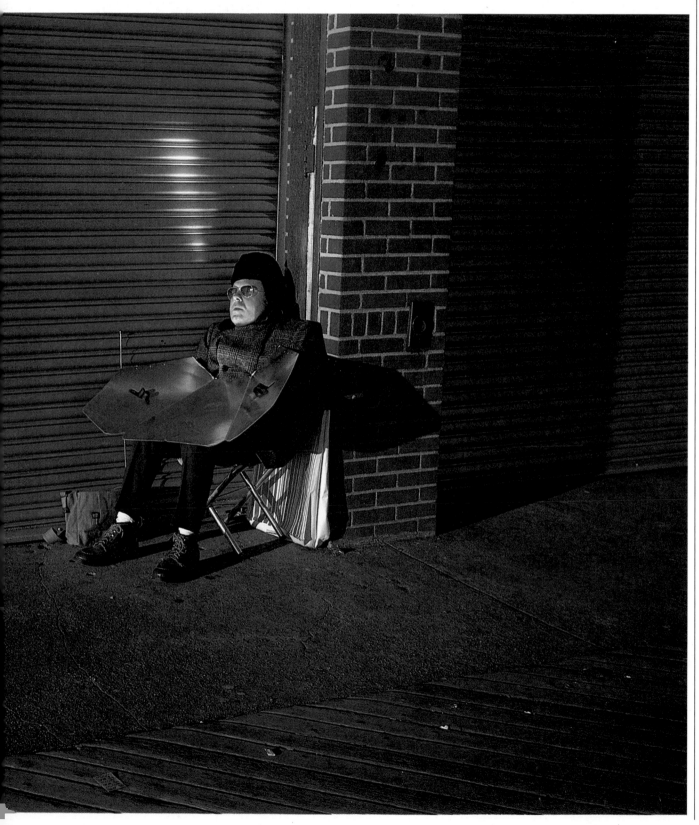

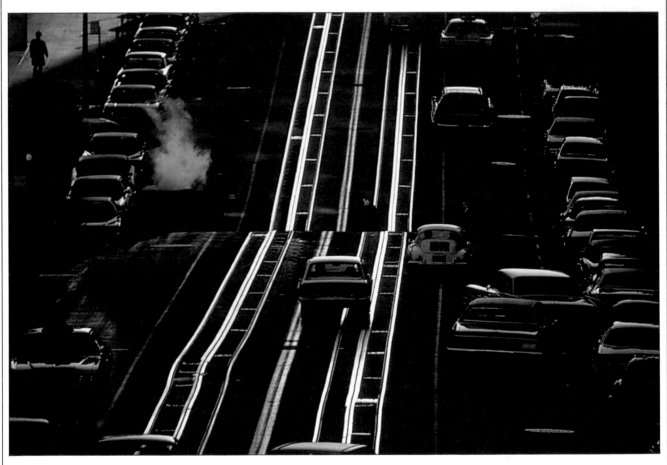

*Streetcar tracks gleam
in the San Francisco evening
sun. The photographer used a
400 mm telephoto lens with
two stops underexposure
to give a brooding effect.
The compressed perspective
helps to dramatize the
isolation of the figures in
an impersonal sea of cars.*

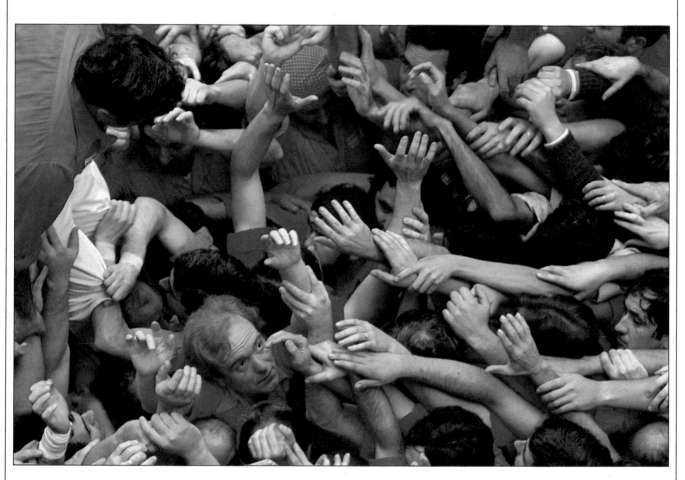

A single face peers up from a confused mass of grasping arms – a turbulent moment during an Easter celebration in Spain, when participants are hoisted aloft in a human pyramid. A 200mm lens closed in on the dense crowd from a high window in a nearby building.

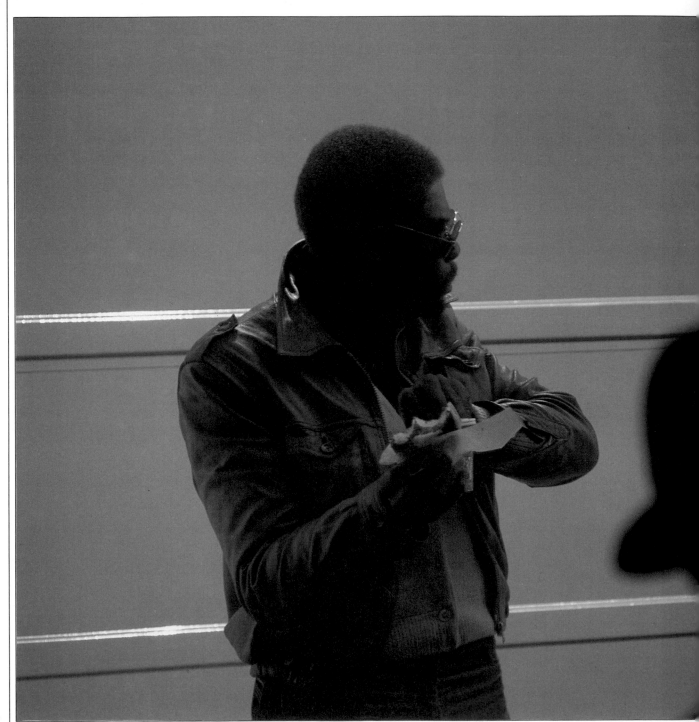

THE CANDID APPROACH

The most natural and lifelike images of people are those in which the subjects seem oblivious to the camera or surprised by it in the midst of the everyday business of living – as in the picture at left. Such candid photography has a long and distinguished history. Photographers past and present have cultivated the art of seeing without being seen and then used their cameras to make incisive social comments. The skills and satisfactions of the candid photographer are equally accessible both to the professional and to the amateur who wants to capture on film unposed glimpses of total strangers or friends.

Today's cameras make this easier than ever before. Compact and unobtrusive, the 35mm camera attracts little attention, and its automatic controls free the photographer to concentrate on the character-revealing expressions and gestures that people often hide when they know they are being observed.

Above all, candid photography means anticipating, waiting and watching for the moment when all the elements of the picture come together in just the right way. If you are alert to such moments and have learned how to melt into the background, your photographs can capture the very pulse of life.

The pace of city life
is caught in an image that
brings together two figures
linked only by the camera's
viewfinder. The photographer
was first attracted by the
vivid wall and the sidewalk
snack. But by waiting to
silhouette a hurrying figure,
he intensified the whole
feeling of the picture.

Using simple equipment

Good candid pictures do not require elaborate or expensive equipment; the effective shot at right could have been taken with any normal camera and lens. However, because candid photography often involves a swift and unobtrusive response to the subject, there are certain features that make some types of cameras more suitable than others.

First, your camera should be quick and easy to use. If you find the controls awkward to handle or sluggish to operate, you may miss a good picture.

Secondly, a shiny, noisy camera inevitably attracts unwanted attention and interest. With SLRs, it is difficult to mask the sound of the reflex mirror flipping up for exposure, but when you want to remain unobtrusive, you should at least avoid using a motordrive, regardless of how useful such an accessory may be at other times. To make a camera less obvious, cover the shiny parts with black tape.

The rangefinder cameras shown at far right are especially suitable for candid photographs such as the one below. They are compact and light in weight, and they lack the reflex mirror of an SLR, so they are quieter. A rangefinder camera also has another, more subtle, advantage. Because the viewfinder shows more of the subject than will finally appear on film, you can observe figures just outside the frame – and therefore more easily anticipate when they will enter the picture.

Shadows on a wall
(right) look like children's paper dolls in this unusual view of a rodeo. To avoid the conventional cowboy clichés, the photographer turned from the real action and pointed his camera at these striking outlines.

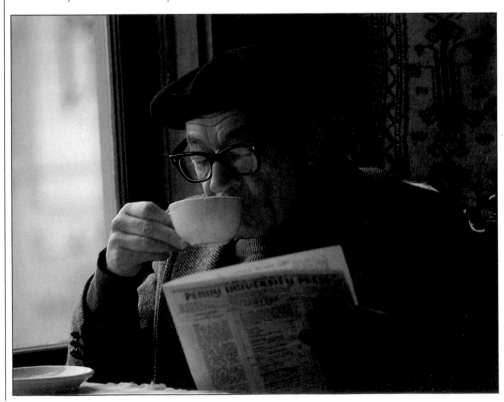

Coffee and the news *(left) so absorb this man that he ignored the photographer, who was seated at the next restaurant table. The almost silent shutter of a rangefinder camera permitted a series of photographs without interrupting the subject's morning reading.*

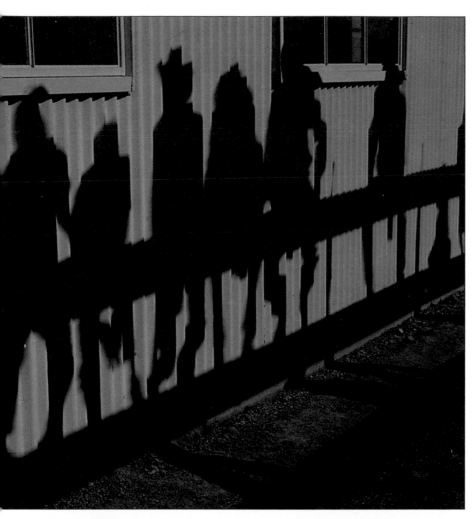

Candid cameras

Even the simplest of single lens reflex cameras is more than adequate for the demands of candid photography, but the smaller, quieter models, such as the Pentax ME (above), attract less attention.

Rangefinder cameras are still better than SLRs, because they are much less noisy. The classic tool of journalists is the Leica (shown above) – a precision rangefinder camera made to take lenses ranging from 21mm to 135mm.

Other rangefinder cameras, such as the Olympus XA (above) and the Minolta CLE (below), are almost as quiet as the Leica, and a fraction of the price. They are usually smaller, too; both these models fit into a pocket.

The viewfinder of a rangefinder camera offers significant advantages for candid photography. Bright lines mark the edges of the frame to reveal what is happening at the fringes of the camera's field of view. By comparison, the viewfinder of an SLR shows slightly less than appears on film.

Down on the beach, the photographer says more by showing less. He used an SLR with a standard 50mm lens to snatch this tightly framed and witty vignette.

Being prepared

Opportunities for great photographs rarely present themselves on cue but seem to appear when you least expect them. To cope with such surprises, try to carry your camera as often as you can, even if you are not planning to take any pictures.

So that you can react quickly to unforeseen circumstances, keep your camera out of its case, but with a UV filter or lens cap on for protection, and always remember to advance the film after each exposure. Nothing is more frustrating than spotting images such as the ones here and whipping the camera to your eye only to find that the shutter does not release because you forgot to cock it.

Keep the controls set to approximately the right exposure. On an overcast day outdoors, just one setting will do, but when sunlight creates higher contrasts, you will need to work out two settings – one for sunlit subjects and another for those in shadow.

You can speed up focusing, too. Instead of leaving the camera adjusted to very near or far distance, set the focusing ring on a normal or wide-angle lens to about 15 feet so that you need make only minor adjustments before taking a picture. At small apertures, you may not need to focus at all, because depth of field extends to cover subjects from about seven feet to the far distance.

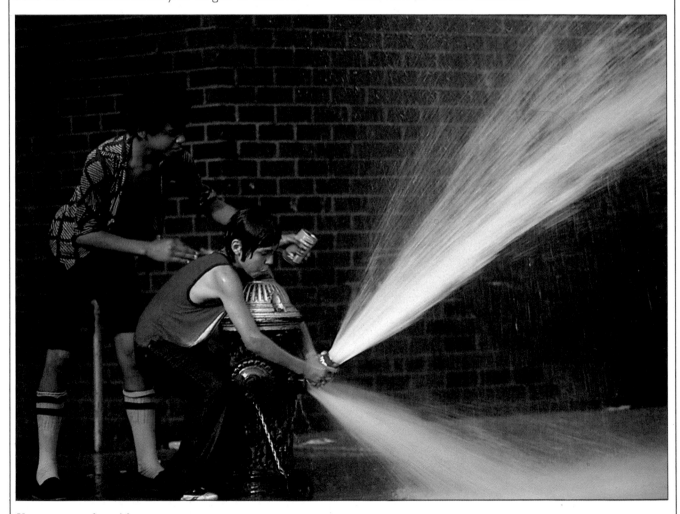

Youngsters play with a
fire hydrant on a New York
street in summer. A preset
shutter speed of 1/500 let the
photographer capture the
best moment in the action.

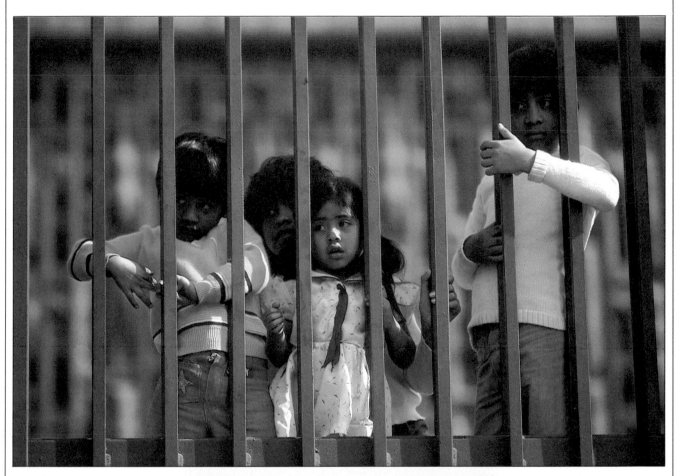

A playground fence casts broken shadows across faces behind it. To cope with the contrasts, the photographer quickly found an exposure halfway between the settings he had prejudged for the sunlight and the shadows.

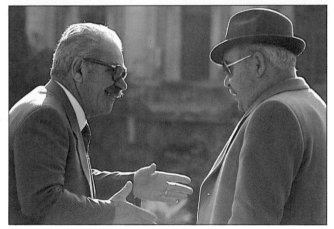

A street debate shows the value of presetting as the photographer could raise his camera on the spur of the moment without attracting his subjects' attention.

The automatic method

Because automatic cameras adapt instantly to varying light or distances, they are ideally suited to taking pictures such as the one at right on the spur of the moment. However, to make the most of an automatic, you must accept its limitations and use it intelligently; no camera can think for itself.

When relying on automatic exposure control, take care that the range of light intensities does not exceed the camera's auto-exposure range. For example, if you set a shutter-priority automatic camera to a slow speed such as 1/30, the camera will cope well with dim light, but in bright sunshine even the smallest lens aperture will not cut down the light enough to prevent overexposure. Conversely, in dim light, an aperture-priority camera set to f/16 will select a shutter speed that is too slow for a handheld picture. By anticipating these possibilities, you can choose a setting that will allow the camera to function properly regardless of the light.

Autofocus gives you extra speed in picture-taking, and you can use this to get spontaneous pictures that take advantage of surprise. With the camera hanging from its strap, get into a position where the background and composition look about right for the anticipated subject. Then raise the camera quickly to your eye, and press the shutter release without hesitation. Always compose the picture with the subject at the center of the frame; the camera's distance-measuring system ignores subjects that are off-center, which can lead to incorrect focus.

Autofocus cameras

All autofocus cameras work well in bright light, but some are not so effective in dim conditions — when focusing in the normal way is also more difficult. Try out the camera in a dimly-lit corner before buying one.

An autofocus compact camera such as the one above can do almost everything for you, automatically advancing the film and firing a flash when light is dim. This camera uses an infrared beam to focus, so that the autofocus works even after dark. All compact autofocus cameras have fixed lenses, which tends to limit their versatility.

A confirmed-focus SLR such as the one above indicates the point of sharp focus as you turn the focusing ring, or can provide fully automatic focusing with a special motorized lens. Such cameras retain the versatility of all SLRs, and may be no bigger than those that lack the autofocus facility.

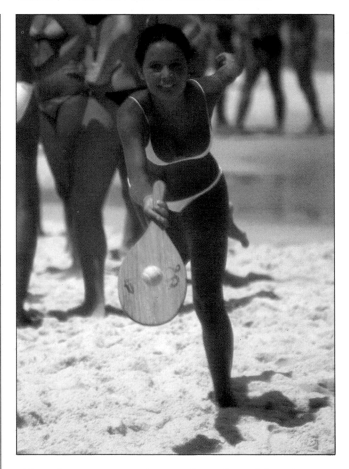

A beach game presented the photographer with a subject that was rapidly moving and therefore hard to focus. A compact autofocus camera brought the girl into sharp focus even when she was running toward the camera or away from it.

A carriage driver in New Orleans passes by, and an automatic camera catches his expression. A speed of 1/250 on a shutter-priority camera allowed the photographer to react fast, confident that the camera would cope with the exposure in the bright sun.

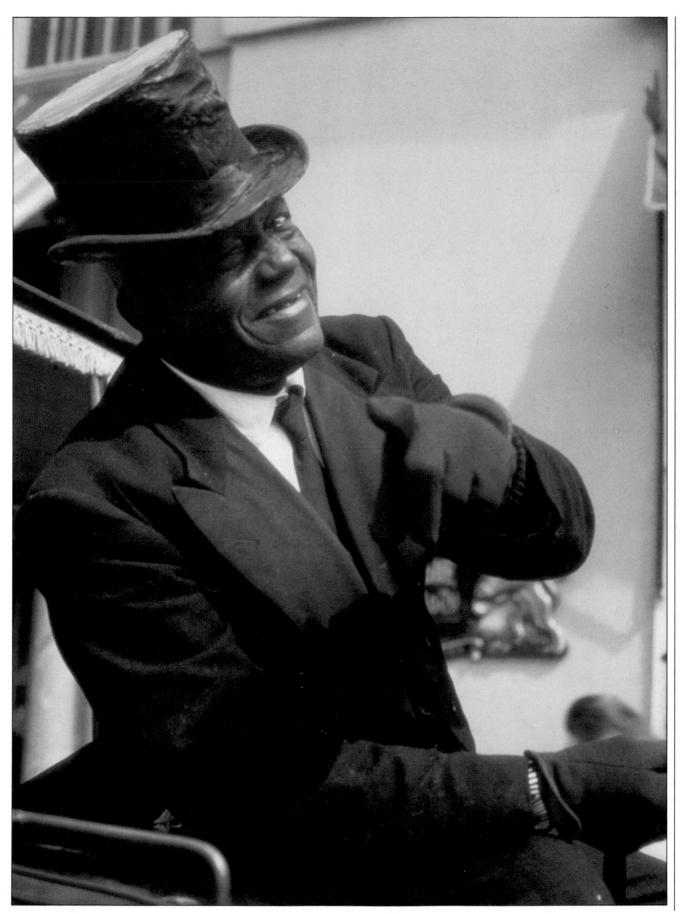

The snapshot style

Candid pictures do not need the polished technique and perfect composition of more considered types of photography. On the contrary, the imperfections of the hastily taken snapshot – figures awkwardly cut off by the frame, elements out of focus, inaccuracies in exposure – can actually add to the sense of reality and authenticity. They stress the picture's immediacy as a spontaneous image – the record of a passing moment in real life.

The impact of the pictures on these two pages comes from their content rather than their purely photographic qualities. They show how the photographer's alert eye and quick reactions to an action or expression can capture a little slice of life. Even if you do not adopt this approach as a permanent style, you can use it occasionally. When you see something interesting that you know will last for only a second, do not hesitate. Take the picture fast, without even thinking of the technical considerations. You will be surprised at the number of worthwhile photographs you get – images that otherwise would have been missed altogether.

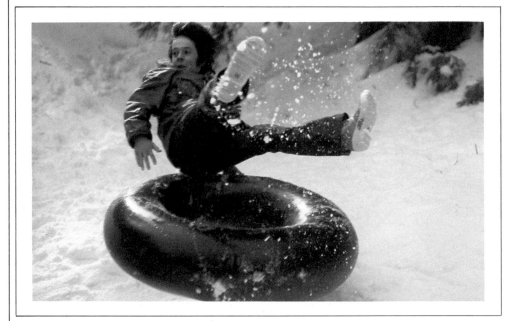

An inflated tire tube provides a youngster with a makeshift sled. A shutter speed of 1/1000 stopped the boy's motion, the excitement of the image more than compensating for the very close framing.

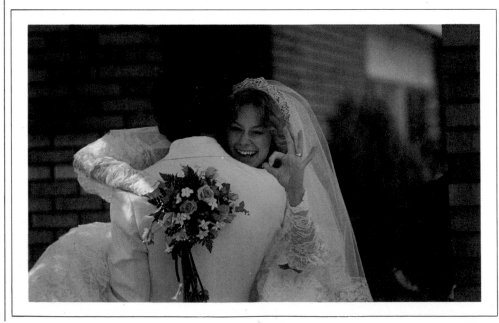

A spontaneous gesture as the groom lifts up the bride conveys the warmth of the moment. The liveliness of the photograph outweighs its technical flaws – the crooked verticals, the figure intruding from the right and the background that is neither very sharp nor wholly blurred.

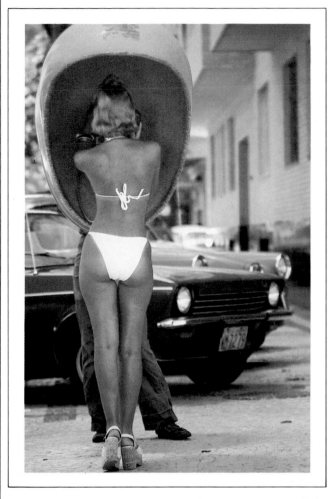

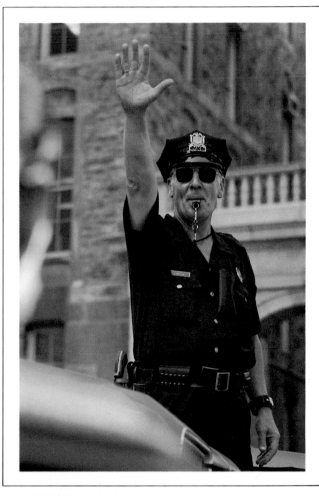

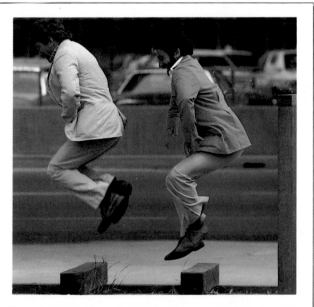

A bathing beauty (above) makes a call from a phone-booth near the shore. A quick snapshot caught the incongruity of the moment.

A traffic cop (above) calls a halt. Using a normal lens, the photographer simply crouched down quickly and recorded the expression.

Two friends (left) leap over a row of wooden posts in spontaneous play. The photographer, relying on fast reactions rather than technical skill, snapped the scene before it passed.

The planned element

Photographs that seem candid can result from planning most of the composition in advance. With this approach, you gain control over the content of a picture without losing the sense of spontaneity achieved in a snapshot.

The secret of making setup pictures look uncontrived is to balance planned elements with a lively, unstaged point of interest. In three of the pictures on these pages, a figure crossing the frame and unaware of the camera's presence gives a strongly candid feeling to carefully contrived compositions. In each case, the photographer spotted a good setting and anticipated the effect when the right subject came into view.

Sometimes this perfect combination of setting and action may not fall into place naturally, or you may not be in position with your camera at the right moment. Asking someone to stage or repeat an action may result in the subject looking stiff and self-conscious. An alternative approach is to use a prop to complete the picture as in the image at left below, in which a colorful hat conveys the flavor of Venetian life as effectively as would a portrait of the owner.

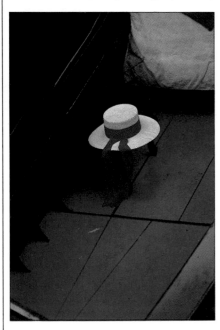

A gondolier's straw hat (above) *captures the flamboyance of life on the canals of Venice, Italy. The photographer planned each element in the composition with the boatman's cooperation, yet the result is natural and spontaneous, right down to the casual placing of the hat.*

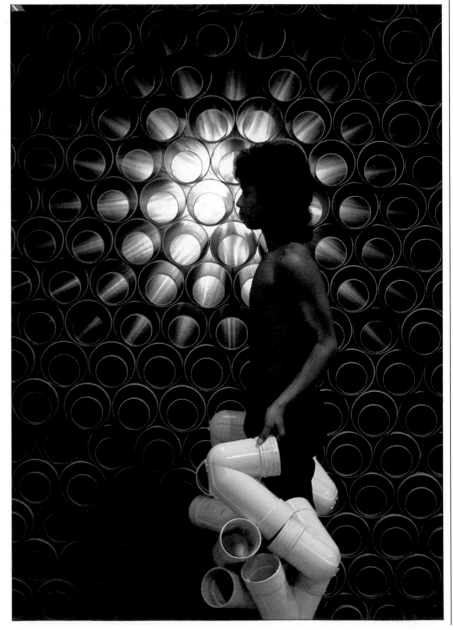

A wall of plastic pipes (right) *forms a patterned backdrop for a factory worker in Singapore. Noting the effect of the light shining through and highlighting the pipes, the photographer set the camera's controls and waited for the subject to move into the frame.*

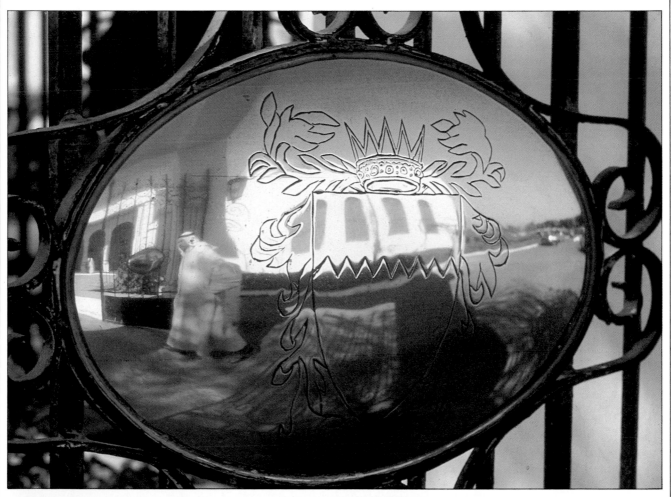

A polished plaque (*above*) on the gates of the ruler's palace in Bahrain reflects a scurrying figure who is quite unaware that his picture is being taken. The photographer used a 28mm lens so that the reflected buildings as well as the foreground subject were in focus. Distortion caused by the convex surface of the plaque helped to suggest the shimmering heat.

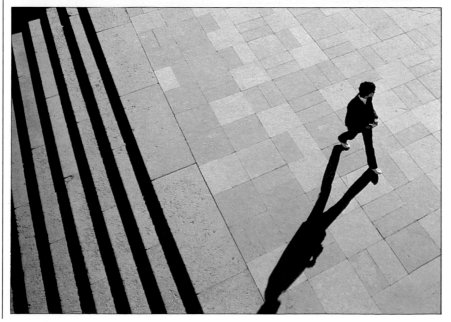

A man walking across a deserted concourse is dwarfed by his lanky shadow. Attracted by the strong, graphic lines of the setting, the photographer chose an overhead position and waited for a lone pedestrian to enter the scene.

Dealing with people

The most completely candid photographs are taken without the subject's knowledge. But there is a limit to the kind of pictures you can take this way. More often, you will need some degree of cooperation from people to obtain a satisfying result.

In most circumstances, a friendly manner and a smile will do the trick. If you look solemn, people may start to wonder just why you are photographing them, whereas a smile can disarm their anxieties and help to put them at ease. How close you move in with your camera is another important factor. People may well object to a photograph if they feel you are becoming too intrusive. By keeping his distance, the photographer who took the picture at right relied on the subjects' passive acceptance and

did not need to seek their active cooperation. People with something they are proud to display are more likely to respond to a direct approach. For example, a friendly interest in the garlic seller's work resulted in the sparkling picture below.

Legally, you do not need to seek permission from people you want to photograph in public places if the pictures are for personal, editorial or exhibition use rather than for a commercial purpose such as advertising (when written permission is required). However, judge the situation carefully, do not invade people's privacy, and be ready to defuse things with charm and tact. Sometimes, even mildly hostile reactions can be turned to good effect, as the picture at left below shows.

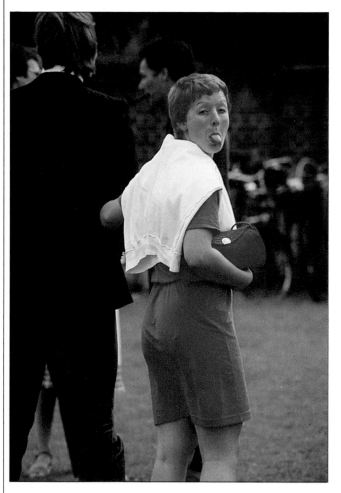

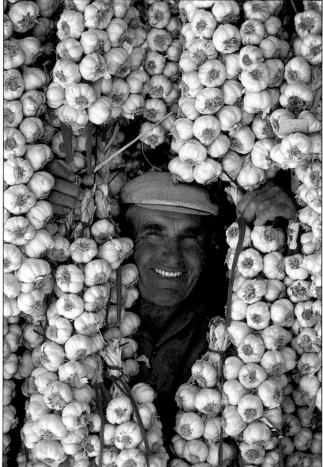

Taunting the photographer, a young woman tries to spoil his candid picture. The pink tongue toned in perfectly with the subject's carefully color-matched outfit and hair, making an unwittingly humorous and unexpected picture.

The grinning, weathered face of a French garlic seller peers out from among his wares. Chatting to the man about his work encouraged him to show off the skillfully strung bulbs — resulting in a posed but delightfully personal shot.

A couple relax on a park bench in
the evening sun. By keeping his distance,
the photographer avoided the risk of
making the subjects self-conscious. He
underexposed to bring out the strong tonal
contrasts of sunlit and shaded areas.

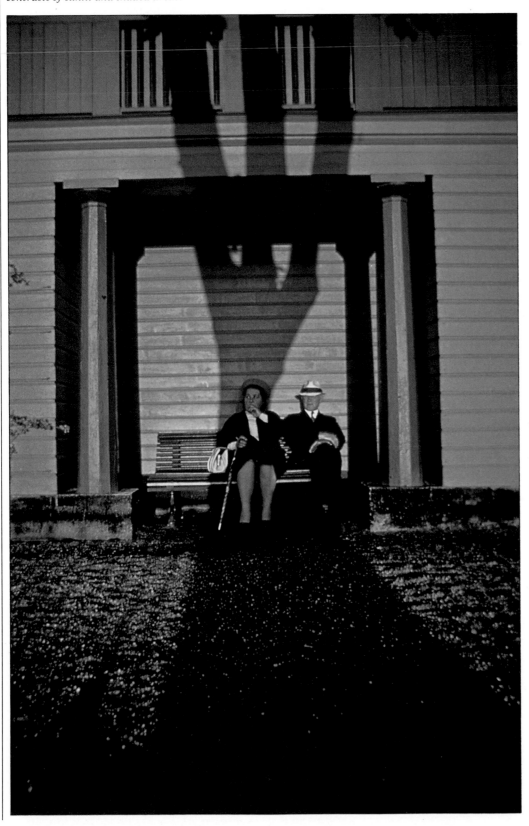

The unseen camera

Picturing people at their ease is simplest if your subjects do not notice the camera, or at least are unaware that you are taking photographs of them. The sight of a photographer raising a camera to his or her eye is an automatic warning and may make people stare or become self-conscious, even if they do not object to being in the picture.

Without resorting to subterfuges such as aiming your camera through a hole in a coat, there are some straightforward ways to make yourself and your camera inconspicuous. For example, when your subject is in bright sunlight, stand in deep shadow, as the photographer did for the picture below, left. A door or window – especially a car window – makes an excellent observation point for candid pictures of street life. So does the kind of

unusual viewpoint that produced the picture of a young couple at the bottom of this page. Because people rarely look up, a high position can help you to remain unnoticed.

You will also be less conspicuous sitting down than standing up, especially if you have a long lens, as used for the picture on the opposite page. For close subjects, such as the table conversation going on below, a wide-angled lens has the great advantage that you do not need to focus or aim it precisely in order to get good candid pictures. Aim away from the subject to set a suitable focus and exposure, then leave the camera on a table or hung around your neck until you see the picture you want. The lens's wide field of view should let you take quick approximate aim without raising the camera to your eye.

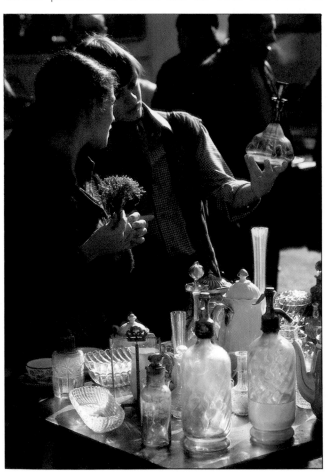

A sunlit junk stall attracts young shoppers. Hidden from sight in a shop doorway, the photographer used backlighting to reveal details of the glassware.

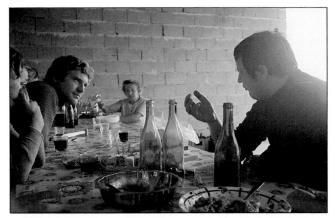

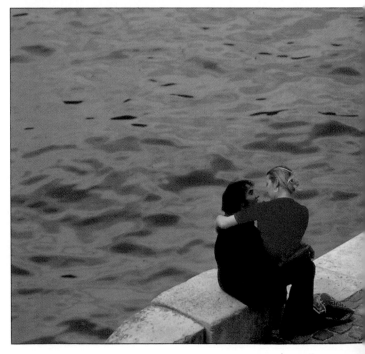

Vineyard workers (*left*) *converse after dinner. To remain inconspicuous, the photographer lifted the camera barely above the table, and took the picture without looking through the viewfinder.*

Riverside lovers (*below*) *do not think to look up, so the camera that peers over the bridge parapet above records a wonderfully natural moment of intimacy.*

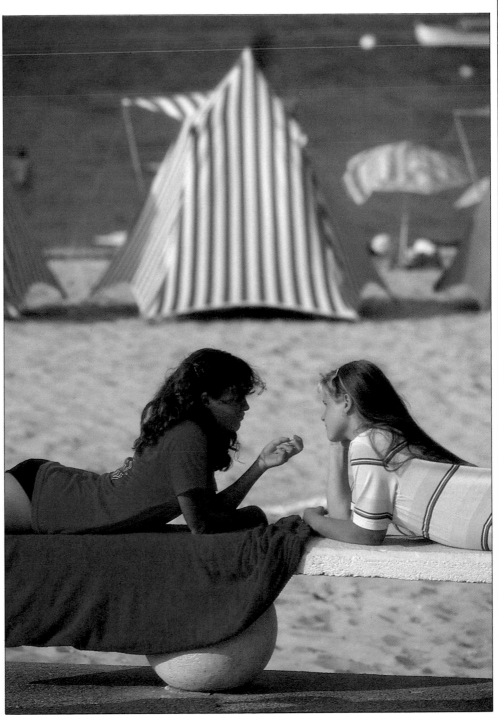

Two teenagers absorbed in conversation ignore the photographer, who sat at a picnic table opposite and focused his telephoto lens on another subject before he turned toward the girls.

31

Taking a sequence

When you are responding quickly to a situation, often there is not enough time to study the scene and judge what will make the best picture. In these circumstances, using a motordrive attachment to take a smooth, uninterrupted sequence of frames increases your chances of getting at least one good image. A motordrive is also useful if you want a strip of frames to tell a story, as in the sequence at right.

A motordrive on the continuous setting allows you to make exposures at a rate of several frames per second as long as the shutter release is depressed. This sounds like the ideal way of getting the moment you want on film, and in exceptional circumstances it is – for example, if you witness a sensational news story and want to record as much as you can of the rapidly unfolding drama. But there are disadvantages. The noise of continuous motordrive makes it self-defeating for most candid work, where the aim is to go unnoticed. And the peak moment may well happen between frames; the shutter is open for only four or five 1/1000s of a second, and closed the rest of the time.

Usually, a better technique is to use the single-frame motordrive setting, which gives you the convenience of automatic film advance but allows you to control when each exposure is made. The series on the opposite page, taken on Derby Day at Epsom, England, shows the advantages of this technique: several almost identical exposures produced one with extra sparkle.

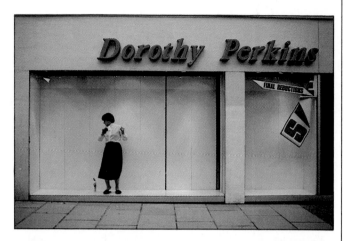

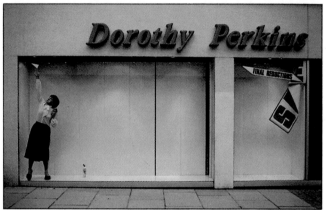

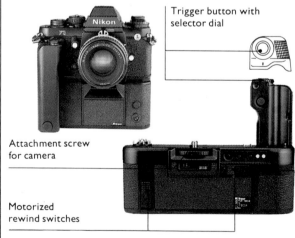

Using motordrive
A camera with a motordrive attached (top), and the attachment itself with its selector dial, are shown above. The continuous setting, C, automatically advances the film at up to six frames per second while the shutter is depressed. The single-frame setting, S, gives automatic advance, one frame at a time. The lock mode, L, prevents accidental use of the motordrive. A motorized rewind switch lets you change film quickly.

Trigger button with selector dial

Attachment screw for camera

Motorized rewind switches

A window dresser removing stickers from a store window looks almost like a mannequin – until we see her shift her position. By using a motordrive on the single-frame setting, the photographer was able to take a sequence of the subject's candid actions without moving the camera, and so create a small picture essay from the strip of frames.

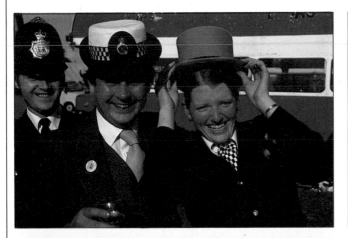

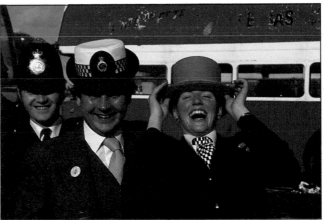

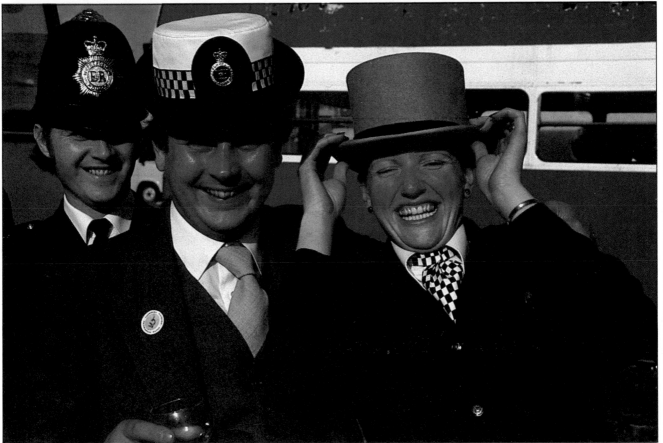

A policewoman (at right) and a racegoer
try on each other's hats on Derby Day. Each
picture captures the infectious gaiety
of the event. But the photographer could
not be sure that he would record the best
from all three subjects in only one image.
By taking several frames with a motordrive,
he obtained the one directly above, with
just the right smiles.

Wide-angle views

A wide-angle lens can put people into context. Its broad, sweeping view of the world not only takes in the figures that form the principal subject but also can surround them with important details that tell a story. For example, a wide-angle lens added to the picture below by taking in not only the auctioneer but also his assistants and the bids overhead.

In a similar way, the picture at the bottom of the opposite page owes its impact to the balance between the pale figures with their colored towels and the surrounding blackness of the stones and beach. The sunbathers would have filled the whole frame had the photographer used a normal lens from the same viewpoint.

With a wide field of view, moreover, you can focus on people who are not aware that the lens is putting them in the picture at all, let alone as the main subject. For example, the fisherman in the image below ignored the camera when he saw the photographer pointing it at the dog.

The extra depth of field of a wide-angle lens makes possible dramatic compositions that sweep the eye back to distant figures or that link the foreground and background. If you stop down the lens to a moderate aperture, such as f/8, and move in close to the foreground, parts of the subject near the camera will loom large and remain sharply focused, creating an arresting image such as the one opposite.

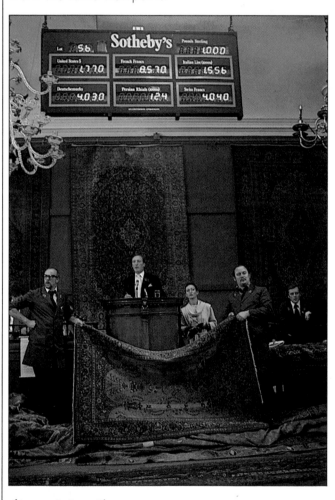

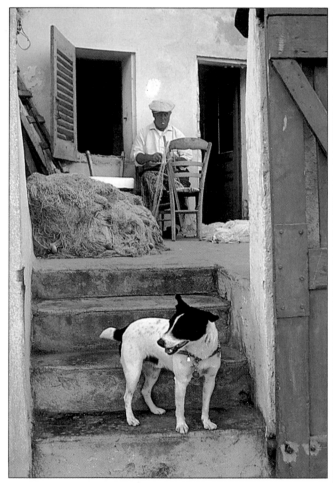

At a carpet auction,
a 28 mm wide-angle lens
enhanced the feeling of
tension and expectation by
recording the spiralling
bidding on the display high
above the auctioneer's head.

A fisherman's dog yaps
on the steps of a courtyard,
and by using a 35 mm lens
and feigning interest in the
animal, the photographer
caught an unposed view of
its master mending nets.

A row of geese awaits buyers in a small, traditional French market. To exaggerate the startling nature of the display, the photographer stooped down and framed the birds with a 24 mm lens, so that they dwarfed the row of shoppers behind them.

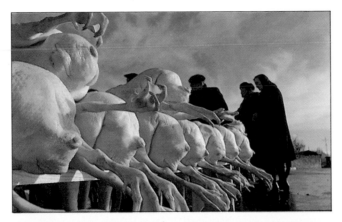

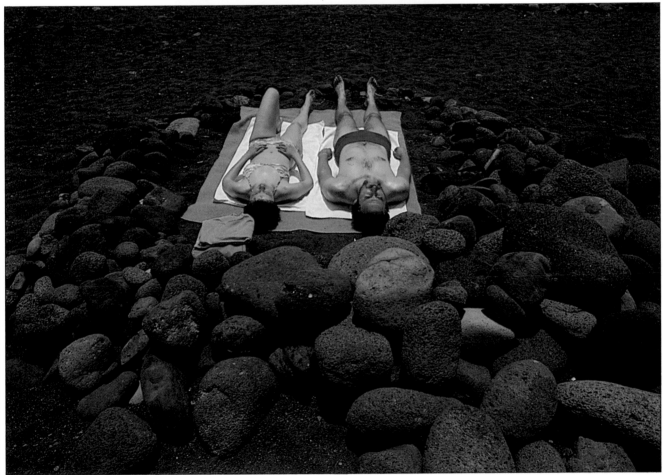

Sun worshippers barricade themselves on a black beach. To show them clearly and yet exploit the tonal contrast between their bodies and the surroundings, the photographer used a 28 mm lens, taking in a broad expanse of sand.

At close range

Wide-angle lenses can give a special flavor to candid photographs, because often they force you to move closer to your subject. With this kind of lens, if you are some distance from the people you are photographing, their faces will appear small and featureless.

Moving closer forces you into a more intimate relationship with your subject. At a distance of only a yard or so, there is no way to conceal the fact that you are taking photographs, so your subjects will inevitably respond to the camera.

If a subject is not self-conscious, the response can create tremendous impact – as demonstrated by the furrier's amused acknowledgment of the camera in the picture at right. But for street photographs, using a wide-angle lens demands confidence and a friendly manner on the part of the photographer; this approach is not for the faint-hearted.

When using a wide-angle lens, take care that close-range distortions do not spoil the picture. Compose the image so that faces are near the center of the frame, as in the picture below. Distortion is most evident at the corners of the photograph, where at worst it can stretch a person's head to an unsightly oval shape.

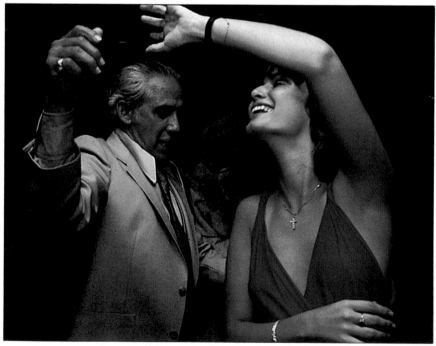

A woman twirls from her partner's hand toward the camera only three feet away. The picture's intimacy comes from a 28mm lens's ability to put the viewer almost into the dance, while showing the subjects clearly and catching the mood of the setting – a Miami nightclub.

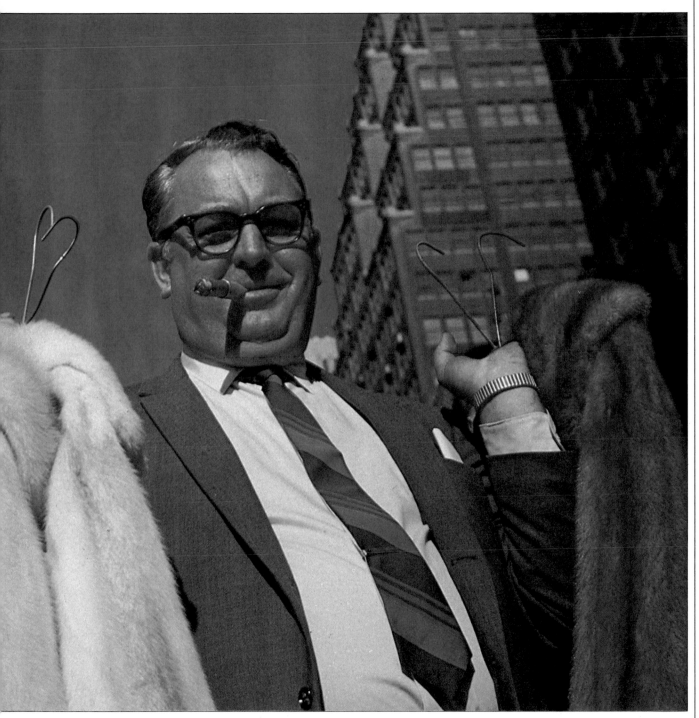

A cigar-chewing furrier greets the camera with an affable smile. Crouching low, the photographer used his 35mm wide-angle lens to crop out distracting street details, framing the man against blue sky and converging buildings.

From a distance/1

Looking through a telephoto lens has the effect of immediately increasing your choice of picture framing within a single scene. Due to the lens's narrow angle of view, shifting the camera by just a small amount can change the image in the viewfinder completely. As a way of viewing daily life, a telephoto lens thus tends to focus the attention of the photographer on detail. You begin observing much more closely and deciding exactly which aspect of a subject to isolate in the frame or which faces to pick out from a crowd – as shown opposite.

With a zoom lens, such as the 80-200mm lens shown below at left, the framing possibilities from a single viewpoint are still greater, because you can change the focal length – and therefore the magnification – at will. This not only gives you more versatility but also saves you valuable time that would be spent changing lenses.

To prevent camera shake, telephoto and zoom lenses require more solid support than do other lenses, yet a tripod may be too conspicuous and cumbersome for many situations where you want to take candid pictures. To avoid these disadvantages, you may be able to steady the camera using the techniques diagrammed below. Alternatively, load the camera with high-speed film, so that you can set a faster shutter speed and handhold the camera without the risk of camera shake.

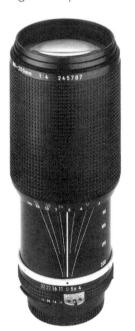

Zoom lens range
For many candid situations, an 80-200mm zoom lens, such as the one illustrated at left, offers an ideal range of focal lengths, as the series of photographs below shows. The lens here is of the usual one-touch type, with a ring that rotates to focus the subject and that also slides along the lens barrel to adjust the focal length. From the 80mm position at which this ring is set, focal lengths up to 200mm are marked along the lens barrel. The splayed colored lines indicate the depth of field for each aperture, narrowing as the focal length increases.

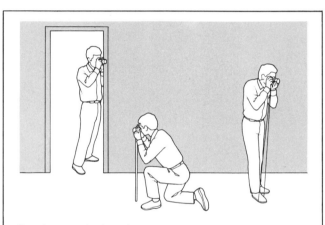

Steadying a telephoto lens
To support the camera firmly without a tripod, press it against a solid surface (above left), or use a monopod (center), which is less clumsy than a tripod and almost as steady. A cord looped underfoot, and attached to the camera's tripod socket, forms an improvised brace (right).

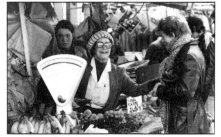

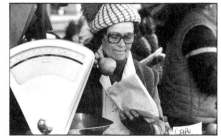

80mm setting
At its shortest focal length, an 80-200mm zoom lens took in all the hustle and bustle of a busy open-air street market.

135mm setting
Zooming the lens to a longer focal length enabled the photographer to close in on one vendor and her customer.

200mm setting
The longest focal length setting made possible a tightly cropped portrait of the vendor at work.

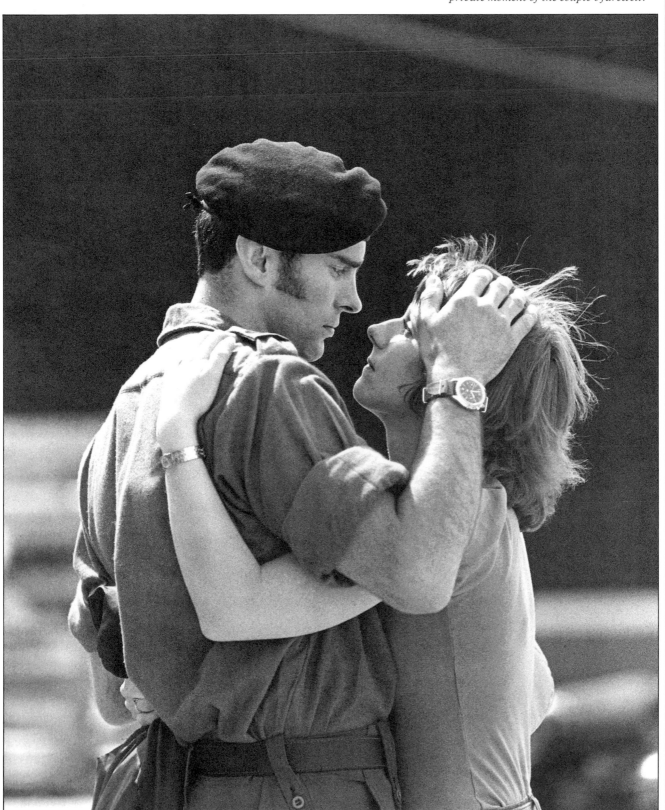

A quayside embrace as a British soldier leaves for war in the Falklands encapsulates the emotions of all such leavetakings. The photographer fitted a 300mm lens, to avoid intruding on the private moment of the couple's farewell.

From a distance/2

A distant viewpoint frequently provides intriguing insights. Psychologically, standing back from a subject and using a telephoto lens means you can be more detached and objective. And, because you can be unobtrusive, you will usually have more time to compose the picture.

Sometimes you need to be far enough away not to disturb a particular mood – as in the picture at left below of an old woman enjoying the leafy seclusion of her garden. On other occasions, a telephoto approach can enable you to capture dramatic moments such as the one below right. Here the impact of the photograph depends entirely on the

children's unawareness of the camera. A longer lens may also be preferable for creative reasons – as in the picture on the opposite page, where compressed perspective exaggerates the pattern of flags and feet.

For most candid photography, a medium range telephoto lens – 100mm to 200mm – is the best choice. A 100mm or 105mm lens, for example, by doubling the focal length of a normal lens, enables you to pull in the middle distance but is still light and compact and offers a wide maximum aperture of f/2.5 or faster. This makes focusing quick and easy, because the focusing screen shows a brighter image than longer lenses can provide.

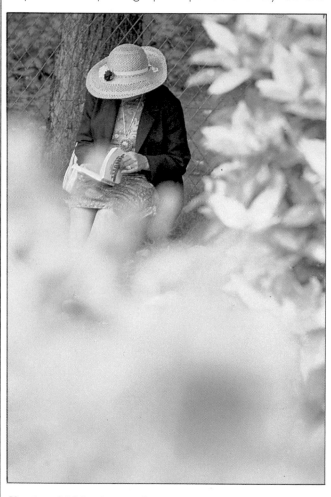

Her face hidden by a sun hat, an elderly woman relaxes in her garden with a book. The photographer used a 200mm lens and took advantage of a screen of foliage to avoid attracting attention. The unfocused blur of greenery also helped to establish a mood of serene privacy.

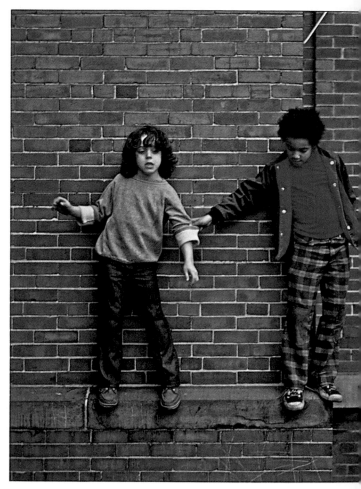

Schoolchildren play a precarious game of balance on a ledge outside their classroom. With a 135mm telephoto lens, the photographer was able to close in on the tense expression of the child about to lose his foothold without the risk of distracting the friends from their game.

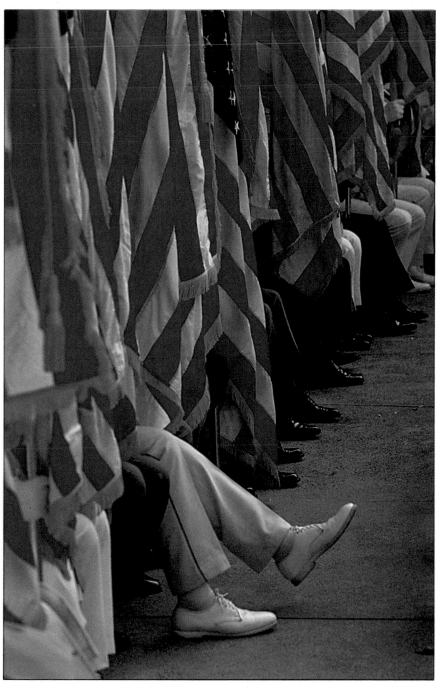

Stretching his legs, *one participant provides a human touch in this image of Veterans' Day at Arlington Cemetery, Virginia. A 105 mm telephoto lens had the effect of compressing the neat row of flags and polished shoes, thus giving more emphasis to the odd man out.*

Candid portraits/1

Because most people have fixed ideas about how they want to appear on film, pictures that capture them unawares can have a truthfulness or humor that seldom appears in posed portraits. Good subjects for such candid portraits are people who are too busy or too involved with one another to pay much attention to the camera. The bandsman below, who is clearing his trumpet mouthpiece, was less concerned with the camera than with last-minute preparations for an Armed Forces Day performance on the Hudson River at West Point, New York.

Some of the skill of taking pictures like the ones shown here lies in picking out the right face as well as the right situation. Some people's characters can be read instantly from their expressions. For example, in the picture at top right, it was the utter seriousness of a man waiting for the judge in a dog show that first attracted the photographer, who then took advantage of the bloodhound's sudden lurch toward his master's face.

This kind of quick response to an unexpected opportunity has to be combined with watchful patience. If your subject is taking part in a semiformal occasion, or giving a performance, look especially for the moment of relaxation after a period of concentration, as at bottom right.

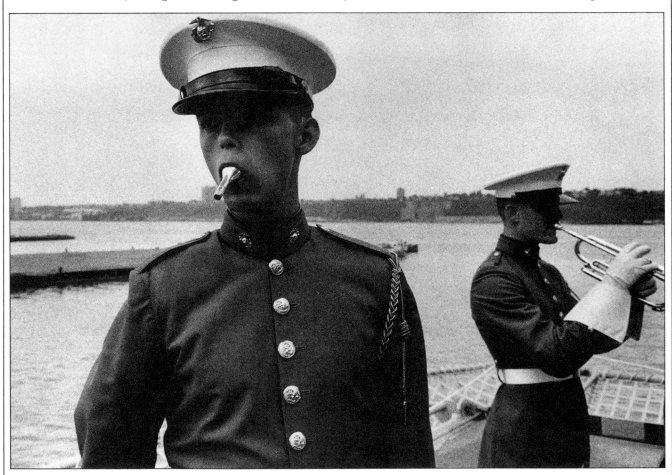

A marine bandsman has his image of stiff formality shattered by a detached mouthpiece. Careful observation enabled the photographer to poke some harmless fun at military pomp. Precise framing was essential to the picture – without the second bandsman at right, the trumpet mouthpiece would be almost unrecognizable, and the picture might not make sense.

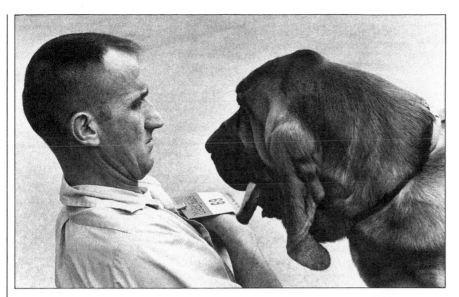

A bloodhound and master seem to inspect each other. By catching the moment when the dog tried to lick his master's face, the photographer made a balanced dual portrait that wittily questions who judges whom at a dog show.

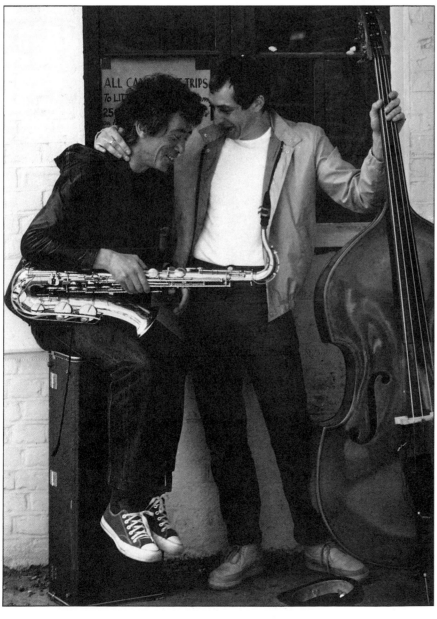

Two street musicians share a joke that breaks the more standard poses they had held while playing. Recognizing that their bantering relationship made a better picture than the performance preceding it, the photographer quickly released the shutter before the next number began.

Candid portraits/2

In a formal portrait, the sitter's eyes are usually the most important feature, expressing character and providing a dominant point of interest. But unplanned portraits can also reveal this expressive quality, without losing the freshness and immediacy of truly candid pictures. In each of the portraits on these pages, the subject is looking directly at the camera, yet the effect is natural and unposed.

The secret of taking such photographs is, above all, to work quickly. A stranger owes you no obligation to cooperate while you set the camera's controls and find your viewpoint. Once your subject is aware of your intentions, any delay will result in unwanted posing, or else in awkwardness and perhaps resentment. Sometimes the best approach is to attract the subject's attention at the last moment – as in the picture at left below.

With a group of people, you can be more open. The man dominating the picture opposite, above, knew he was being photographed but not that he had been singled out from the crowd for a portrait. This image also shows how figures cropped by the edge of the frame strengthen the feeling of a grabbed photograph. In the large picture below, the foreground figure at one side seems included in the frame almost accidentally.

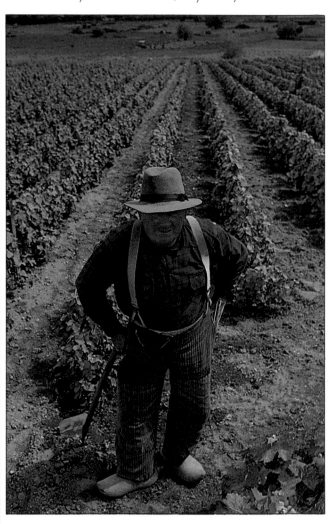

A French farmer looks up from his work with good-natured curiosity as he notices the camera. The photographer used a 28mm lens to include the neat rows of crops, and was all ready to press the shutter release as soon as the subject realized he was being photographed.

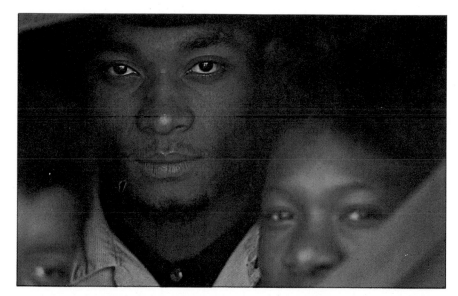

A strong face confronts the camera with an unflinching stare. Spotting the subject's cool, enigmatic expression in the midst of a crowd, the photographer closed in with a 105mm lens at a wide aperture to throw the foreground out of focus. The frame edges cutting into the two out-of-focus faces give the picture movement, depth and immediacy.

A sidelong glance gives candid impact to this unusual portrait. The photographer chose a wide-angled lens and focused on the immediate foreground, using fill-in flash for good definition of the subject on an overcast day. The off-balanced framing suggests that the man has just appeared on the scene.

Street action

Most of us are so accustomed to the pace of life in towns and cities that we tend to overlook its photographic potential. But the ceaseless energy that characterizes urban living can make great pictures.

Two action-photography techniques can help you express the energy of street activity. One is to use a shutter speed slow enough to blur moving cars or people. This will be more effective if you can contrast the moving figures with a sharply defined subject, as in the railway station picture below. Another approach is to pan with one subject to obtain a sharp image against a streaked background.

The varied rhythms of different activities in a city center can make exciting and lively compositions. But make sure that you have a strong focus of interest, such as the road crew in the picture at the bottom of the opposite page, or the impression will be merely chaotic.

Look out for the personal touches in urban life, as well as the overall views of massed activity. In the picture at far right above, the photographer snapped two people laughing after bumping into each other during the rush hour. Even in the most unpromising settings, you can capture surprising, unusual images if you are alert and ready with the camera. A very fast shutter speed enabled the photographer to fix the subject at right in mid-somersault for an offbeat image that enlivens the dull surroundings.

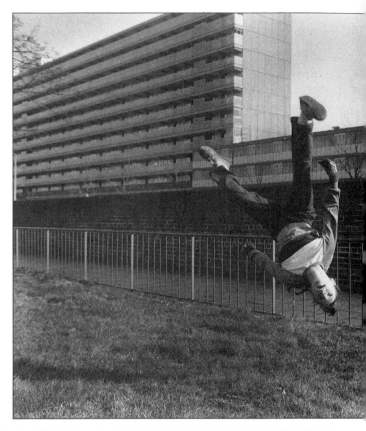

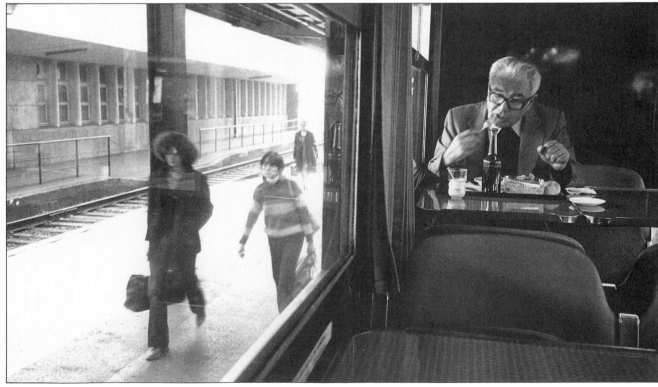

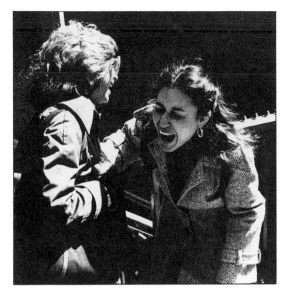

A collision between two hurrying women outside a subway entrance (above) provoked hilarity. Spotting their cheerful apologies as they clung together, the photographer stepped close to them with a hastily aimed 35 mm lens set at 1/500, f/5.6.

A girl (above) executes acrobatic turns on an open space opposite a block of high-rise apartments. Using a 35 mm lens at a speed of 1/1000, the photographer caught the action sharply and included the bleak details of the urban environment.

Road workers (right) disrupt the regular bustle of life on a New York street corner. The photographer set a shutter speed of 1/250 at f/11 for sharp overall detail in a scene of urban confusion.

A passenger (left) enjoys a meal in transit, while life rushes by on the platform outside. By framing to divide the composition in half, the photographer emphasized the contrasting levels of activity.

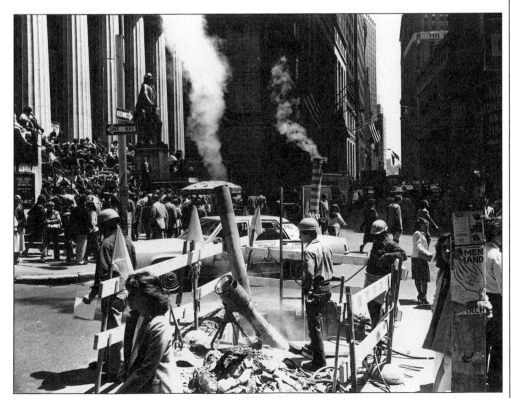

47

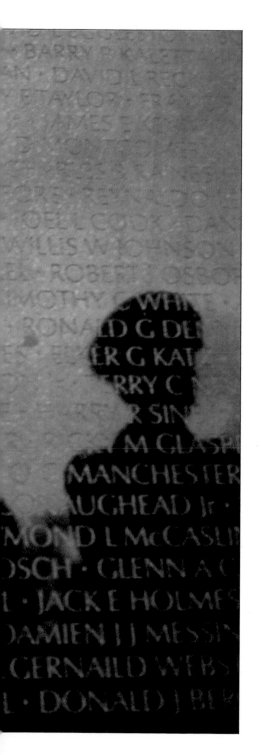

THE PICTURE AS RECORD

Nowadays, newspapers and magazines track every facet of our lives in pictures – from the most transient fads to the great events of our times. Most photographs that make the news, by their very nature, are usually of only temporary interest. But some, because of an accident or because they capture an enduring element of human concern, transcend the moment of the event and achieve lasting significance. The famous picture of the Hindenburg in flames was taken by a photographer on a routine assignment to cover the docking. Whenever you attend an event, however small or mundane, be alert to the possibilities – your picture may make an indelible record of history.

But not all pictures for the record are of newsworthy events. Documenting the details of daily life – how people live and work and enjoy their leisure – is worth the best researching and picture-making efforts of a photographer. Moreover, the pictures we take now will have even greater value for the future – and they may be appreciated much sooner than we think. The public fascination with images of the past now extends to quite recent photographs, of the customs and conditions of 20, 10 or even five years ago.

Shadow figures searching out the names of fallen friends and relatives give personal meaning to the haunting image of a public tribute – the Vietnam veterans' memorial wall in Washington D.C.

News and documentary

Few photographs contain the tragic drama of the plummeting aircraft at right below. Such incidents are thankfully rare, and although every photographer dreams of catching an exclusive picture that may be syndicated around the world, the bread-and-butter images that land on newspaper or magazine picture editors' desks are usually much less startling. Most often, photographs are sought that distill the essence of a complicated and ongoing event into a single picture that "says it all."

If you know something about the issues behind the news, you are more likely to be able to do this than someone who is totally ignorant of the story background. For example, the photographer who took the picture at right knew that the Divis Flats area of Belfast was likely to be a flash point for Irish

Republican anger after an inflammatory incident, and he headed straight there. The threatening mood of his picture shows that such knowledge can pay off.

Many publishable pictures accompany feature stories that inform us about events or issues of a more general nature, less tied to a specific occasion. And instead of the single, hard news picture, three or four images may be required to build up an impression of what is going on. You might need to make several visits to a location to put together this kind of picture essay. Even so, look for ways to make each photograph memorable as well as informative. A good documentary image, such as the one at left below, is arresting enough to make the viewer want to find out what is happening by reading the accompanying captions or story.

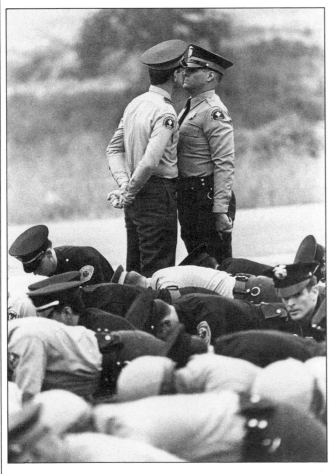

An apprentice sheriff receives some close attention. To the photographer, who was documenting the 14-week training course at San Bernadino, California, this moment of confrontation seemed to sum up the toughness and discipline that the instructors instilled in their pupils.

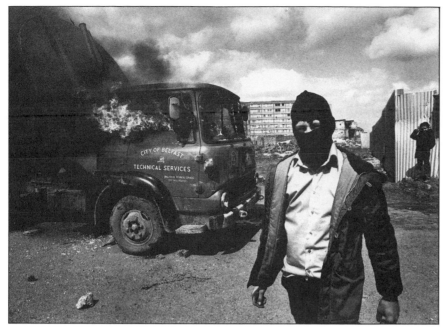

A hooded youth stands defiantly in front of a fire-bombed garbage truck, in a picture that captures the grimness of the Irish conflict. By picking an angle that clearly showed the lettered door of the cab, the photographer was able to fix the image firmly in Belfast.

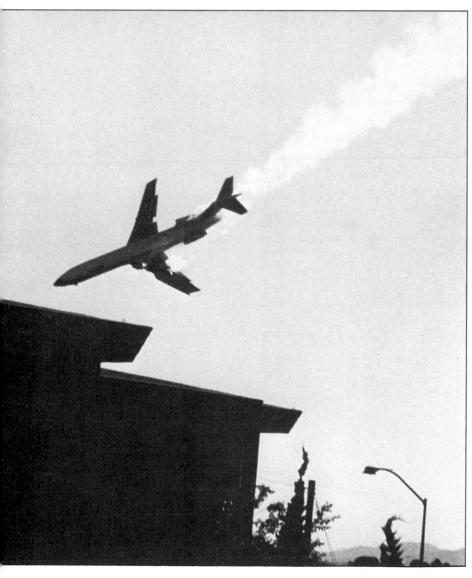

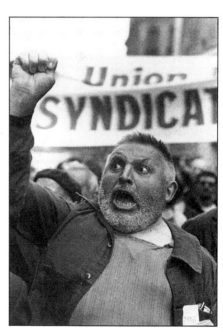

A French trade unionist raises his fist in a traditional gesture of solidarity. The banner behind reiterates the message, so that this single view crystalizes the atmosphere and rhetoric of a huge demonstration.

A burning aircraft plunges earthward in San Diego, and an alert amateur photographed it seconds before impact. The front-page news value of the image more than compensates for its poor composition, providing an extreme example of the value of carrying a camera just in case a newsworthy subject presents itself.

Photojournalism

The first thing to do when setting out to take pictures for possible publication is to start thinking as a photojournalist. This means considering above all else the potential impact of each picture you take in terms of its news value. Put topical relevance before technical quality, although the ideal aim is to get pictures that have immediate public interest and are also excitingly composed, correctly exposed and clearly focused.

Whether or not you have actual publication in mind, you can learn a lot about this task by visiting your local newspaper. And if you approach the editor with a real story idea, you will likely receive valuable guidance, including advice on how to provide full caption information with each picture.

Who, what, when, where and why are the vital questions you will be asked.

Remember that photojournalism is not just about pictures that make immediate news. The image at the bottom of this page and the one opposite have front-page quality, but they might equally well illustrate features on current issues: the health risks of nuclear power and a city's rising crime rate.

Locally, you can find similar photo-feature ideas on a variety of public-interest issues without needing any special access. And if by chance or persistence you happen to be on the spot when something really dramatic happens, a ready camera and some basic facts for captions may put your photographs straight into the newspapers.

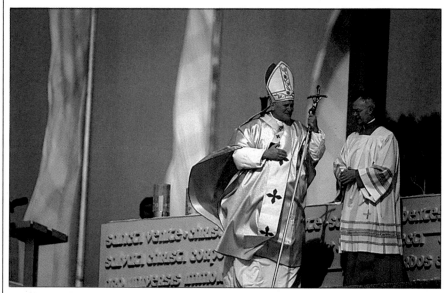

Pope John Paul II conducts an open-air service during his visit to Ireland in 1981. The picture records an event but is also a revealing portrait that might be used to illustrate a profile. Because there was no possibility of getting up close to the pontiff, the photographer used a 600mm telephoto lens mounted on a tripod.

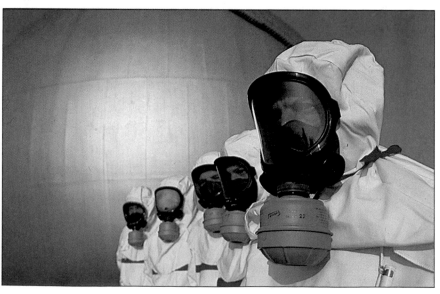

Nuclear-plant workers in protective clothing and masks provide a sinister, futuristic message. With the subjects lined up in front of the globe of the reactor housing, a 35mm wide-angle lens emphasized the foreground worker's grim expression while giving sufficient depth of field to focus the whole scene sharply.

Police deal with a street incident in nighttime New York. The hastily parked auto, the harsh flashing light, the cool efficiency of the officers and the detail of an unperturbed pedestrian in the background all contribute to the sharp realism of the picture. The photographer parked his own car so its headlights picked out the details of the scene.

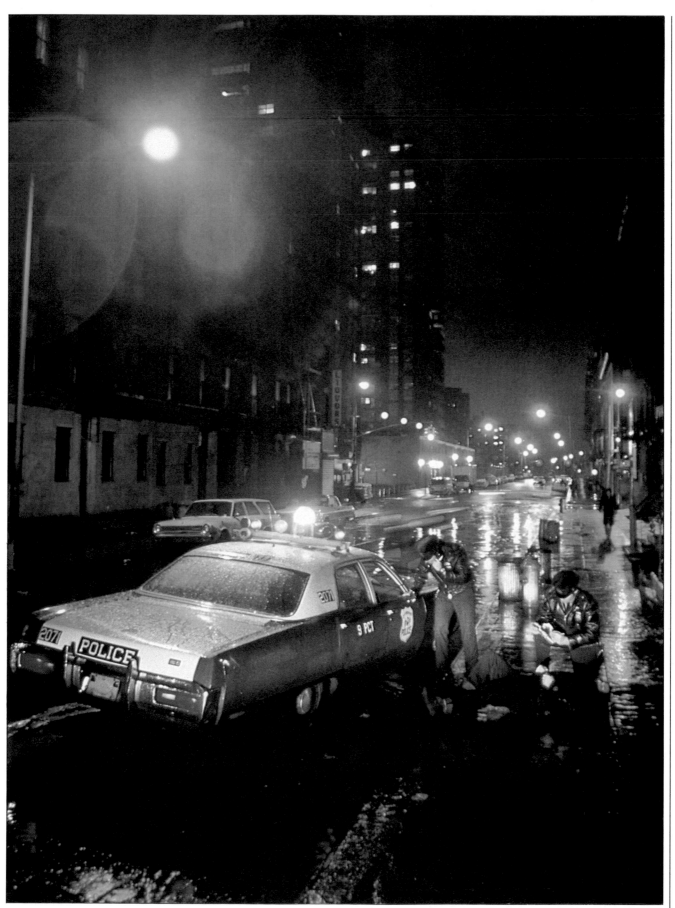

Techniques for photojournalism

The photojournalistic approach requires you to respond instantly to rapidly changing events, particularly when the subject is street action, as in the lower picture on the opposite page. If you are encumbered with heavy equipment, you may miss the best pictures, so take only what you can carry without difficulty. The box at bottom right shows a good basic outfit with two cameras and two lenses, though in cramped surroundings a wide-angle lens of about 20mm is useful too. For outdoor events when you cannot expect to get close to the main subject, you could pack a long telephoto lens, such as a 400mm, as well as a zoom lens to close in on action that is nearer the camera.

Aim to get the most comprehensive coverage that you can. For example, use a range of different camera angles – a series of pictures taken from a single position can look very dull. Add variety by taking some pictures from very close to the subject, then stepping back and using a telephoto lens. Look for low and high viewpoints, since pictures taken from above or below often look more interesting than those taken from eye level and can avoid distracting backgrounds. The photographer who took the picture on the opposite page at top crouched down to separate the two foreground mourners from the rest of the congregation at a funeral.

You can also vary pictures by altering the lighting. By using flash, you can draw attention to figures in the foreground, as in the picture below. But do not use flash in low light; available light, if there is enough of it, will usually look more natural.

If there is enough time, try to take both vertical and horizontal pictures. A 35mm frame is very broad in proportion to its height, and if ultimately you want a picture to be considered for a magazine cover, an image taken with the camera held horizontally may not be suitable without drastic cropping. By using both formats, you increase the chance of your picture being accepted for publication.

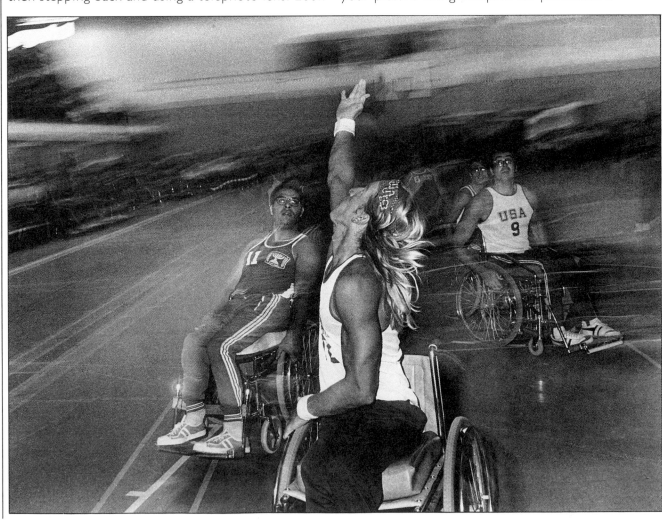

A young mourner sheds a tear at the funeral of her father, the victim of a racial attack. To avoid the harsh intrusion that flash would have caused, the photographer braced the camera and took the picture by the light of the church spotlights.

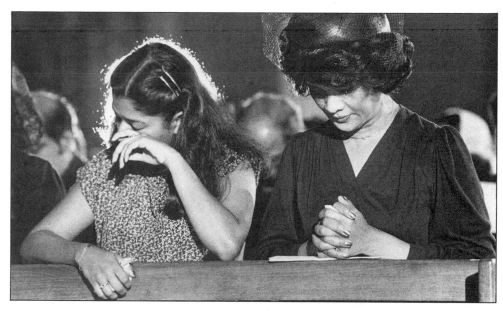

Paraplegic players (left) speed across a basketball court. The photographer used flash to freeze the motion of the foreground figures. But panning the camera with a slow shutter speed of 1/4 streaked the background to suggest the energy and pace of the wheelchair game.

At a street riot (right), two policemen arrest a struggling suspect. To take a series of pictures, the photographer used a motor-drive and picked out this image because it conveyed the youth's terror as he was hustled toward a police van.

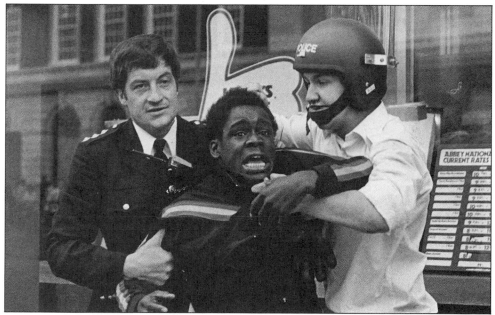

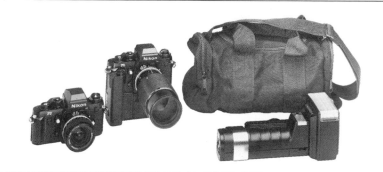

Equipment for photojournalism
Versatility and compactness – vital for fast action – are combined in the outfit at left, which can pack into a soft shoulder bag of the type shown. One camera has a moderate wide-angle lens (28mm), the other an 80-200mm zoom lens and a motordrive to cope with rapid picture-taking. The flash unit (bottom) is useful both for dim light and for filling in daylight.

Simplifying the news image

One of the great challenges of news photography is to find strong, memorable images in surroundings that seem unappealing or are crowded with people.

When one person is the principal subject of a picture, you may find it difficult to isolate the individual from the surrounding sea of faces. You can sometimes achieve this by moving back and using a telephoto lens, as the photographer did for the picture on the opposite page. The narrow angle of view of such a lens excludes the surrounding figures, and because depth of field is shallower, people behind and in front of the subject appear blurred.

You can also concentrate attention by taking the opposite approach – use a wide-angle lens and move closer. If you do this, the main subject will be much nearer to the camera than anything else in the frame, and will therefore dominate the image, as the immense rip in the road does in the picture at right.

With general subjects such as severe weather scenes, look for strong images that tell the story indirectly. For example, the photographer who took the picture below found a burnt-out shop on which fire-hoses had created festoons of icicles, and used this to convey the intense cold. You can use a similar technique to dramatize events that, at a glance, seem visually uninteresting. A competition winner holding a check could make a dull photograph; but if the prize winner is sitting in the motorboat that the money is going to buy, the image should be far more striking.

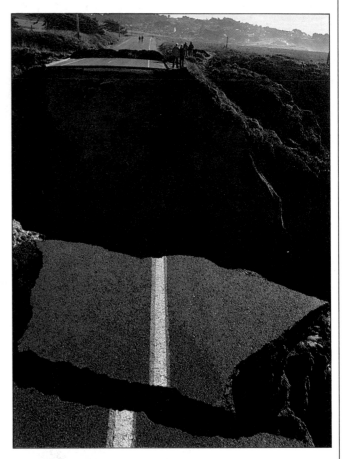
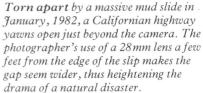

Torn apart by a massive mud slide in January, 1982, a Californian highway yawns open just beyond the camera. The photographer's use of a 28mm lens a few feet from the edge of the slip makes the gap seem wider, thus heightening the drama of a natural disaster.

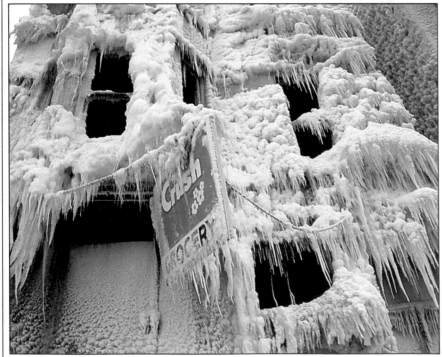

Icicles curtain an empty burnt-out store in Chicago during a bitter winter. The water hosed on to douse the fire immediately froze, to leave a potent image of a city immobilized by cold.

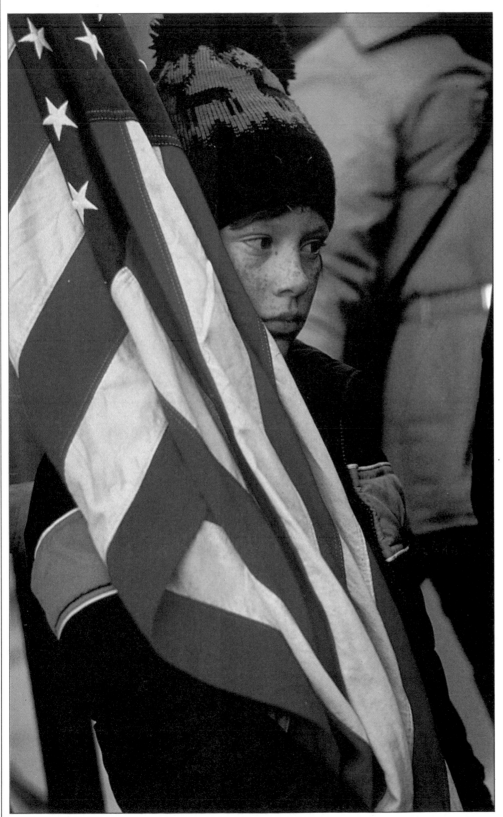

Carrying the flag, this youngster at the 1980 Winter Olympics at Lake Placid, New York, distills the mood of national pride during the games. A 135mm lens picked out the grave face and the flag to make a concise and simple picture.

Cropping for impact

In an ideal world, every picture would be perfect – just as the photographer composed it in the camera's viewfinder. However, few people have so perfect an eye for a picture that they can make the right decision every time; and often there is insufficient time to get everything right. As a result, careful cropping of the print improves many photographs.

The purpose of cropping is to cut out unnecessary parts of the picture that detract from the main theme, or to remove details that contribute nothing. The important areas of the picture that remain can then be enlarged, and therefore carry greater impact. For example, when taking the picture of the starving mother and child below at left, the photographer stood as close as he could without intruding offensively upon their plight. Only after making the print did he see the possibility of cropping dramatically to produce the more powerful image shown below.

If you find it difficult to visualize how a photograph will look when you have cropped it, make a couple of cardboard masks in the shape of the letter L, as shown in the diagram at far right. By moving these around, you can try out several different crops to see how the picture could be improved without actually cutting up the original print.

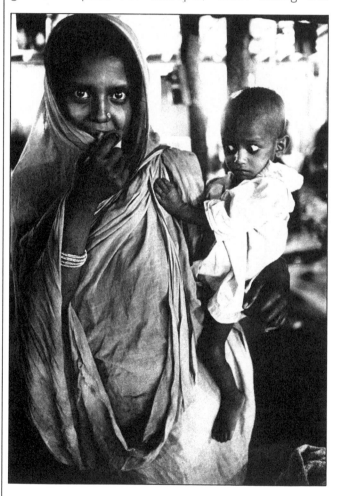

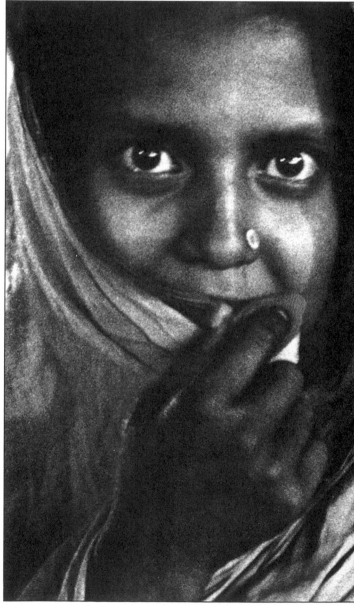

Cropping without cutting

Two L-shaped masks help in deciding where to crop images. Make the masks from stiff cardboard, slightly larger than the biggest prints you use. After studying the various options pick the best crop, then mark it on the print with a grease pencil. Should you later change your mind, you can erase the pencil markings by rubbing gently with a wad of cotton.

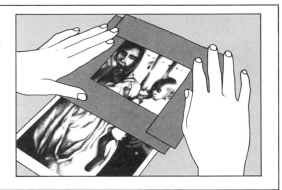

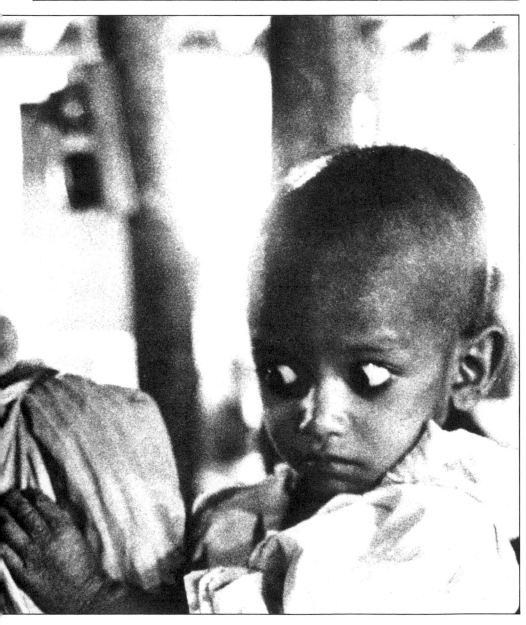

A mother and her child, both desperate for sustenance, wait their turn in a food line at a Bangladesh refugee camp. The original print (opposite), taken for a documentary magazine article about refugees, was already disturbing, but when cropped down to a horizontal format to emphasize the eyes, the image became more eloquent still.

The documentary approach/1

The aim of documentary photography should be to tell a story, whether you do so in one picture or 20. Surprisingly, a single image can often say as much about places, people and how they live as a whole series. But making such images an effective record requires careful thought about content and framing.

Knowledge of the subject is the best advantage that a documentary photographer can have. Being informed helps you to judge what to include of a scene and to decide in advance what you wish to convey. In the picture below, familiarity with the location led the photographer to an unusual, behind-the-scenes view of a shanty town. You need not be committed strongly to a particular point of view to document life in this way, but you must study situations sufficiently to understand what you see and to record it clearly.

The most perceptive pictures often result from selecting details from the minutiae of daily life. There was nothing extraordinary about the old woman leaving a synagogue in the photograph at right, except for the haunting quality of the face itself. The photographer's imaginative approach to framing allowed the face to tell its own story.

Sometimes the opposite approach – including the whole of a scene – is necessary to put a subject into context. The picture opposite takes an attitude midway between these two extremes: although the composition was closely framed to emphasize the facial expressions, the curtain backdrop and the glimpse of a piano are sufficient hints that the baby competition was improvised on a small stage.

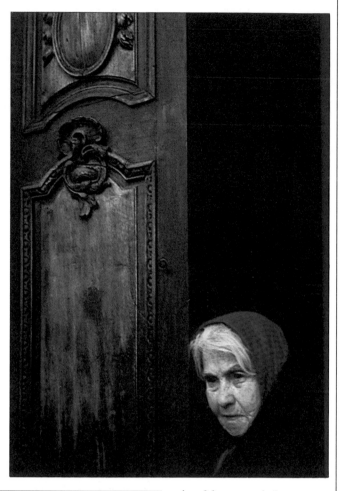

An old woman's face, lined and darkened by a life of harsh poverty, is thrown into relief against the deep shadow of a doorway. The photographer deliberately underexposed by one stop to accentuate the poignant and somber mood.

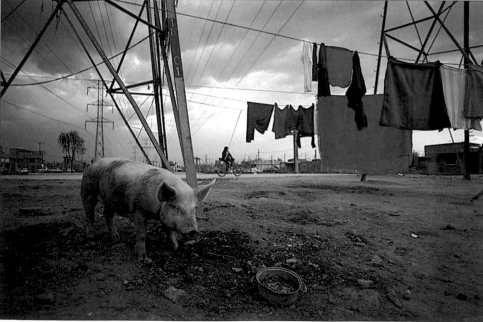

A pig roots among the rubble next to lines of washing strung between pylons on the edge of a shanty town in Mexico City. A 28mm lens exaggerated the foreground elements of domesticity in this bleak urban environment.

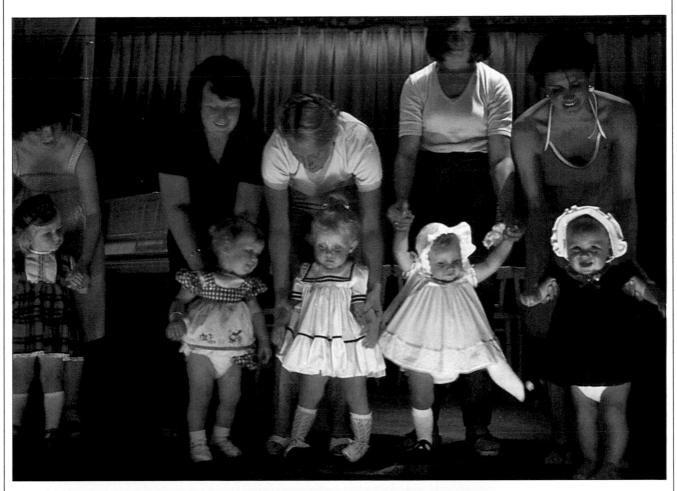

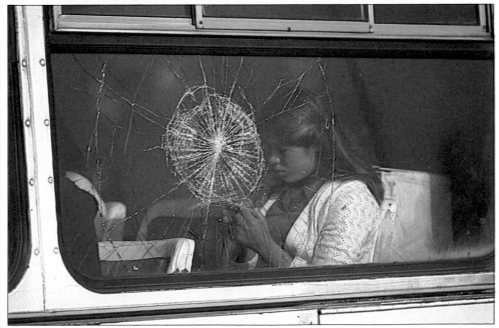

Proud mothers exhibit
their toddlers in a baby
beauty contest at a seaside
town. The photographer used
close framing to exclude the
judges and audience and to
emphasize the two rows of
faces. For the stage spot-
lighting, he exposed at 1/60,
f/2.8 with ISO 400 film.

A young girl (left)
is glimpsed through the
shattered window of a bus.
The pretty, clear-skinned
face juxtaposed with the
image of violence made a
simple but dramatic picture.

The documentary approach/2

Photographing the environments that people live in, work in and visit can reveal a great deal about social conditions, customs and different ways of life. Such pictures may also have lasting archival value – comparing a street scene of 50 years ago with one of today will show fascinating changes. Just as interesting are the features that have remained unchanged, providing us with a visual link to the past.

The pictures on these pages all strongly establish the character of places. Including human subjects that are very much part of their environment gives a clear time reference to each image. In most cases, a wide-angle lens is the best choice for photographing people in their settings. You will be able to include more of the environment, and with a low viewpoint – as in the picture directly below – you can give more prominence to a foreground subject. A telephoto lens is useful if you want to concentrate on part of a view, as in the example opposite.

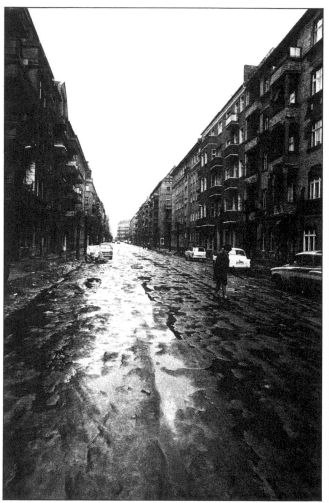

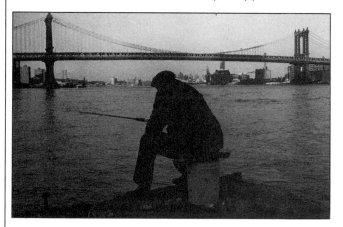

A patient fisherman perches on a garbage can to await a catch. The hunched silhouette and the familiar landmark of New York's Brooklyn Bridge combine to make an unusual image of life in the metropolis.

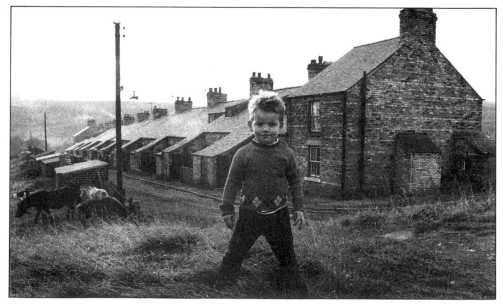

A little boy's stance, tough and defiant, reflects the environment in which he is growing up: a decaying mining village in Wales. The photographer used a 24mm lens to record the details of the terraced house and the windswept countryside.

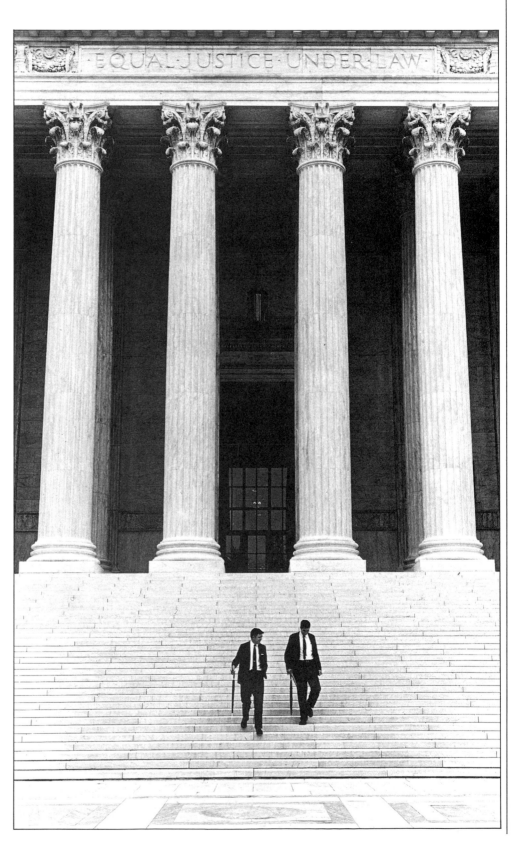

An East Berliner (left) picks her way through the melting snow to her home. This deliberately low-key image, showing the neglected street lined with uniform rows of apartment buildings, is one of a documentary series contrasting life in the two parts of the city.

Dapper colleagues (right) talk as they descend the steps of the Supreme Court in Washington D.C. A 105 mm lens emphasized the huge scale and cool classicism typical of the city's many public buildings.

Customs and traditions

Every community has customs — sometimes kept alive over hundreds of years — that help to give it an identity. Recording these traditional activities is an important part of documenting life.

Annual celebrations are an excellent source of photographs, whether they mark national or religious festivals or purely local events. There is usually a well-planned program for such occasions, so by doing some local research, you can anticipate the sort of pictures you are likely to get and choose your equipment accordingly — fast film for a torch-light procession, for example. Deciding on your subjects in advance will leave you more time to look for interesting approaches, such as the view from the side of the stage of the dancers at right.

There is no need to travel abroad to find exotic traditions to photograph. In large cities with ethnic communities, you will come across diverse customs being carried on within a small area. Most such communities hold their own religious festivals and other unique cultural activities, which can be just as spectacular as those in the country of origin. Indeed, the photograph of Japanese dancers on the opposite page was actually taken in San Francisco.

The color and pageantry of costumed events make them obvious subjects for the camera. But equally fascinating traditions occur at less exotic levels. A horse show, small-town competitions, or a portrait of a local vendor such as the one below can all provide insights for the documentary photographer.

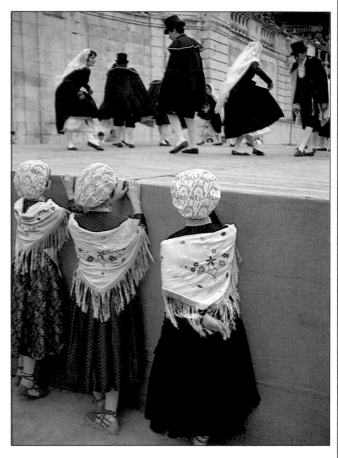

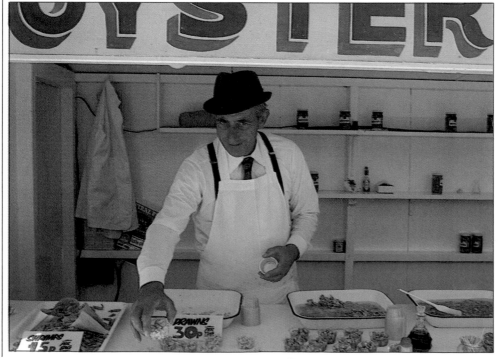

French girls (above) in traditional costumes take a peek at the dancers on stage while they wait their turn to perform. The photographer selected a wide-angle lens to include the details of the shawls in the foreground as well as the formal movements of the dancers.

A shellfish vendor on a London street (left) lays out his wares. Attracted by the typical scene of Cockney life, the photographer moved in close to catch the man's knowing smile, using a 28mm lens to include the trays of seafood with the traditional salt and vinegar dressings.

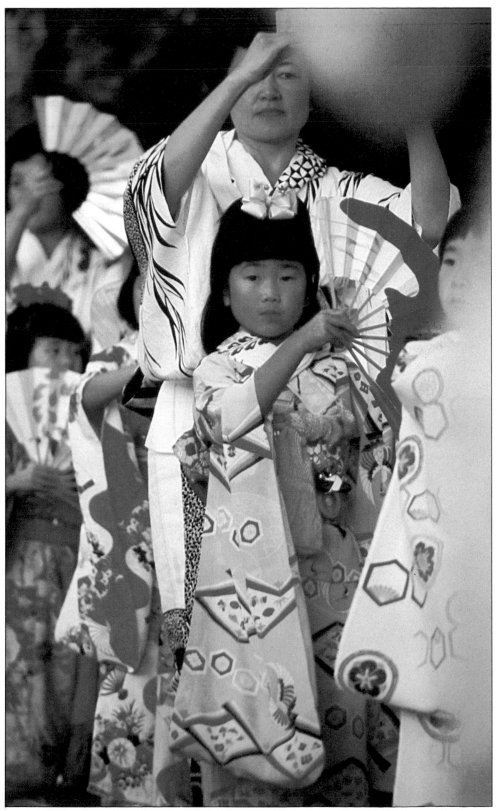

Japanese dancers perform gracefully with fans in San Francisco. A 105mm lens compressed the line of girls to create a kaleidoscope of pattern, color and movement.

The working world

People at work make rewarding subjects, especially when their jobs involve concentration and physical skills or effort; there is something inherently absorbing about watching other people labor. You may need a wide-angle lens to set your subjects in an intelligible context, especially where space is limited. And for many interior workplaces, you will probably need fast film to avoid interrupting the work flow by introducing additional lighting. The gritty texture of fast black-and-white film often suits the nature of the subject.

Tools, machinery and other paraphernalia can be important elements in the composition. But if you are interested chiefly in the human content of a scene, try to limit the amount of detail, either by closing in or by using shadows to hide clutter. In the double portrait below, shooting against the light dramatized the sitter's patience and the artist's absorption. The details are sparse but eloquent – the silhouettes of easel and brushes, the palette with its arresting highlight.

When photographing industrial scenes, planning is crucial. Learn the rhythm of the various processes so that you can anticipate the dramatic peaks. In a busy workplace, the choice of subject may depend not only on what people are doing but also on how interesting their faces are. Sometimes, though, you can make an effective picture out of a worker's anonymity. The welder's face at right is masked by his visor, giving a sense of single-minded concentration.

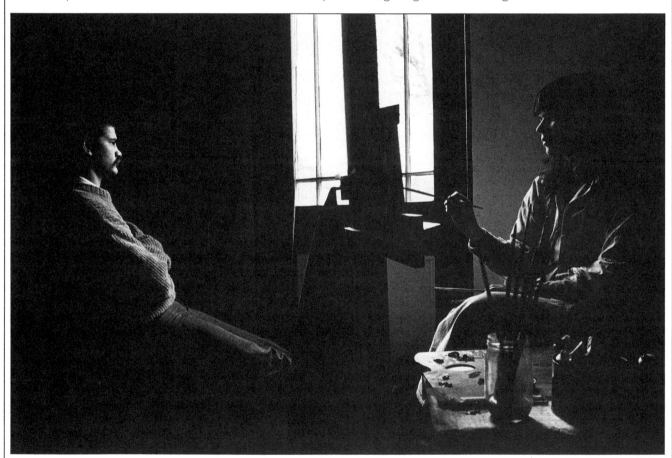

A portrait painter studies her work with unwavering attention. Deliberate underexposure in available light helped to emphasize the involvement between artist and sitter, plunging nonessentials into deep shadow. Using a 35mm lens and fast film, the photographer set his shutter speed at 1/125 to keep the painter's moving hand absolutely sharp.

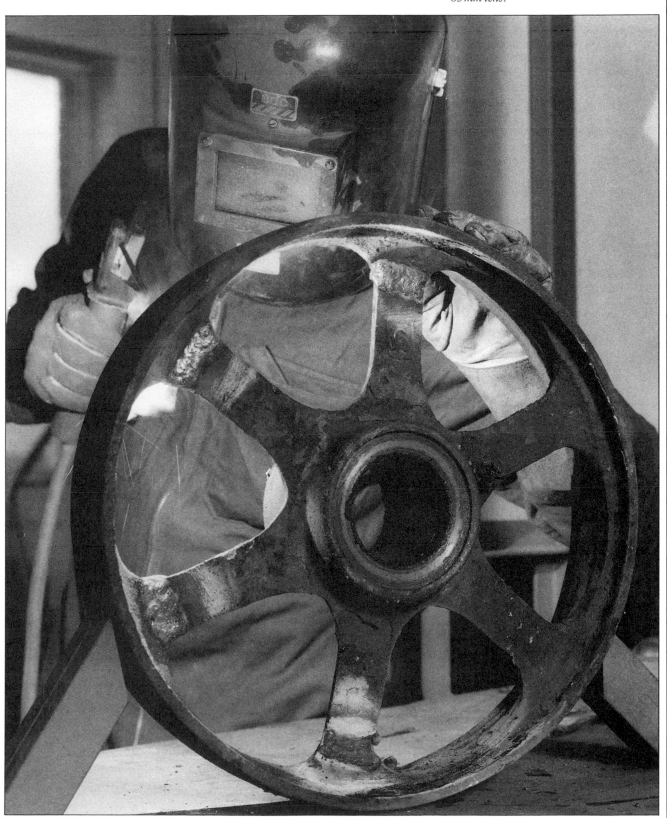

A welder applies his torch to an iron wheel. The photographer, who was fascinated by the rugged textures of the scene, captured the image from a safe distance of 11 feet using an 85 mm lens.

People at leisure

People are often proud of their hobbies and will rarely object to you photographing them. Indeed, they may welcome the chance to show off their skills which can take years of patient practice to perfect.

Once the task in hand absorbs them, your subjects will quickly forget the camera and will look natural and relaxed in your pictures, as do those shown below. You can encourage concentration by being as unobtrusive as possible. A normal or telephoto lens rather than a wide-angle lens will let you put a dis-creet distance between yourself and your subject. Because flash tends to distract people, try to use natural light, even if this means loading the camera with faster film or using a tripod.

Hobbies that are picturesque and frequently photographed carry the risk that your pictures may look stereotyped and dull. This risk is greatest when you take straightforward descriptive photographs. Instead, look for just one feature that will make a strong visual impact, as in the picture opposite.

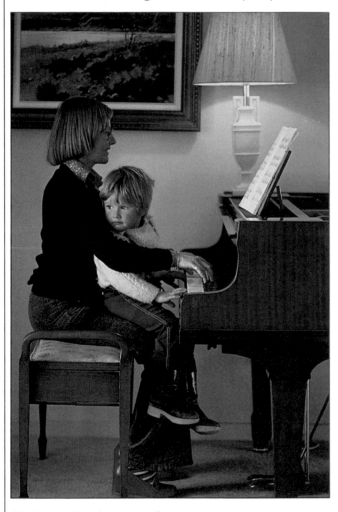

Sitting at the piano, a mother gets some practice with her son on her knee. A table lamp on the piano provided enough light for the picture without flash – which would have distracted the player, and spoiled the atmosphere of tranquility.

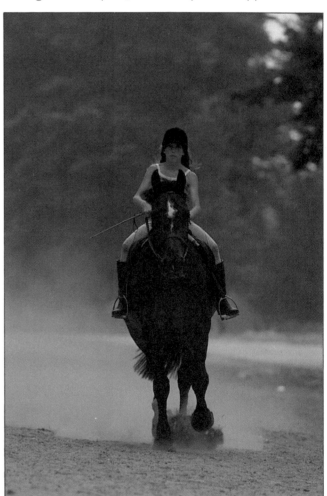

Taking a riding lesson in the park, this young girl is too preoccupied with staying in the saddle to notice the photographer at the side of the track. A 300 mm lens captured her trance-like expression and exaggerated the cloud of dust thrown up by the horse's hooves.

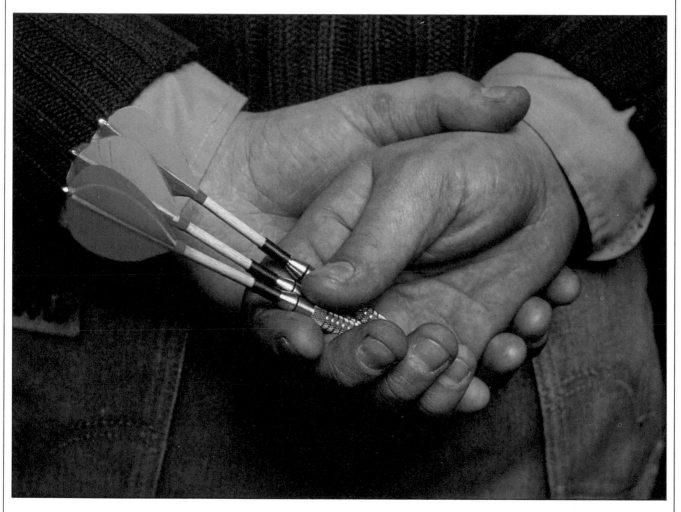

Darts rest in the hand of a laborer
as he awaits his throw in an English pub.
The photographer noticed the man's habit
of holding his darts behind his back and
moved in close to take a picture that
contrasts the traditional pastime with
the hands marked by toil.

An eye for humor

Taking candid photographs offers marvelous opportunities for humor. The expressions and mannerisms of people who do not realize they are being observed may make amusing images in themselves, particularly when they are reacting to something we can see, as in the example immediately below.

Sometimes, you may be able to make use of a visual joke. In the picture at the bottom of this page, the grotesque sculpture seems to mimic the chess player. In other circumstances, you may have to watch and wait for a situation to develop to catch the photograph you want. The photographer who took the picture at right saw the squabbling pigeons flying around the head of an elderly woman and set the controls of his camera in anticipation.

Sparring pigeons (right) *descend on a woman's hat as she scatters bread for some birds from a park bench. The photographer set a shutter speed of 1/15 to convey the sudden, flurried movements.*

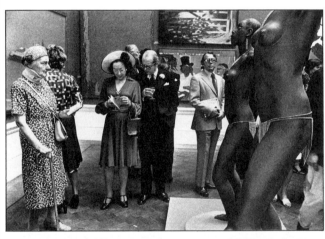

An elderly art lover (left) appraises a lifelike pair of statues, one of which appears to be staring back with disdain. Incongruity between the subjects gives the image its wry humor.

A stone carving (below) at Lincoln Park, Chicago, echoes the thoughtful pose of an open-air chess player. The photographer framed the scene to strongly juxtapose the two subjects.

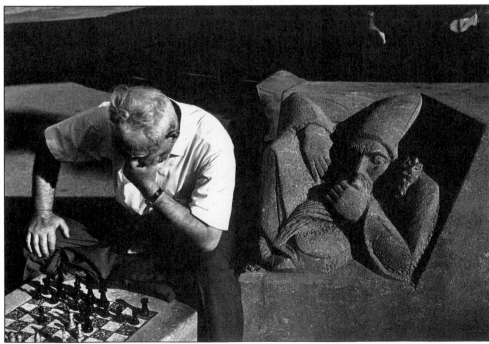

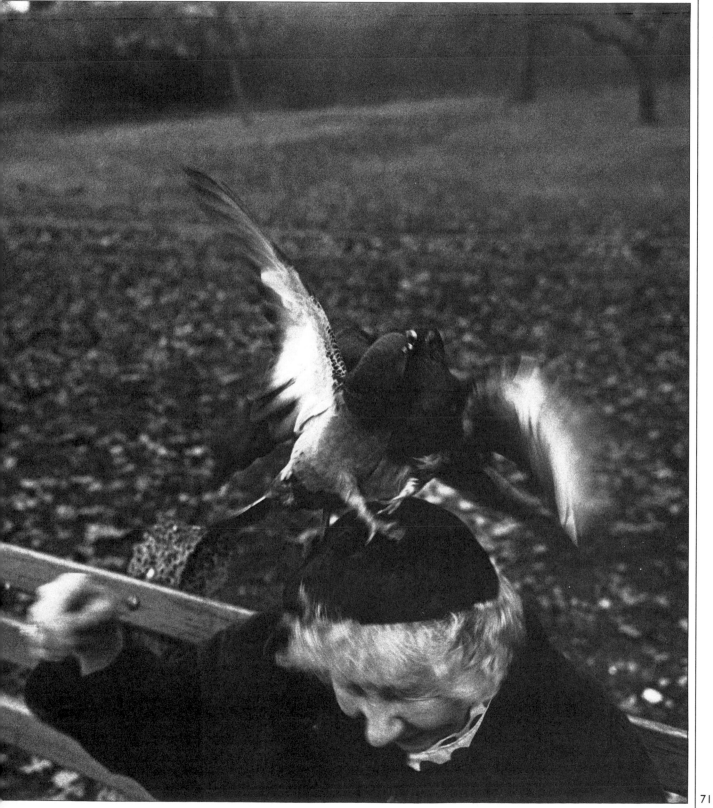

The concerned camera

Photography has a unique power to awaken social conscience. TV news images flicker on a screen for just a few seconds, but still photographs can bring social issues to people's attention in a more lasting way. This is as true of pictures made as a personal record as of images commissioned for posters in support of public appeals.

Sometimes the helplessness or obvious distress of people can present a documentary photographer with an acute moral dilemma. Faced with a harrowing scene such as that of the starving child below, it is not always easy to take pictures. However, if you are genuinely concerned with the plight of the people you are photographing, and are convinced that your photographs can do something – however little – to help them, then your sincerity and good intentions will inevitably shine through. This in itself will help you to secure from the people around you the cooperation that is essential if you are to produce good pictures.

Do not expect to take great documentary pictures within minutes or even hours of encountering a subject. As your involvement grows, so too does the understanding that is vital to a truthful and moving portrayal of human tragedy or crisis.

On a practical level, try to be as sensitive as you can to the feelings of the people you are photographing or working with, and make sure your photographic technique reflects this sensitivity. Keep a low profile by using available light, not flash, and remember that many people are easily intimidated or antagonized by ostentatious display of photographic equipment. So use just one camera, preferably a quiet rangefinder type.

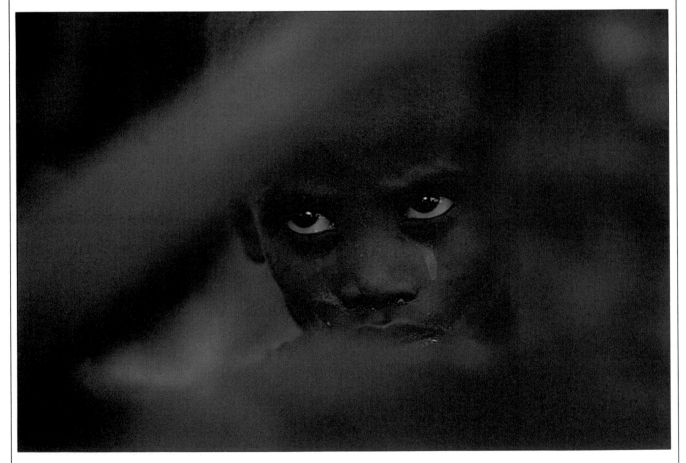

A drought victim's face expresses *personal suffering and symbolizes the plight of all too many others. To draw attention to the boy's pleading eyes, the photographer selectively focused on them, using a wide aperture. The out-of-focus detail in the foreground acted as a frame for the face.*

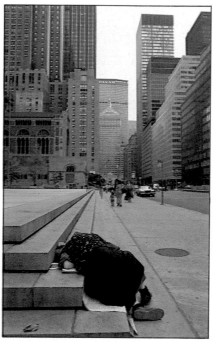

A homeless woman huddles on
New York's Park Avenue, ignored by
passers-by. By composing the image with a
broad empty space around the figure, the
photographer highlighted the loneliness
and sense of isolation that rootless people
often encounter in big cities.

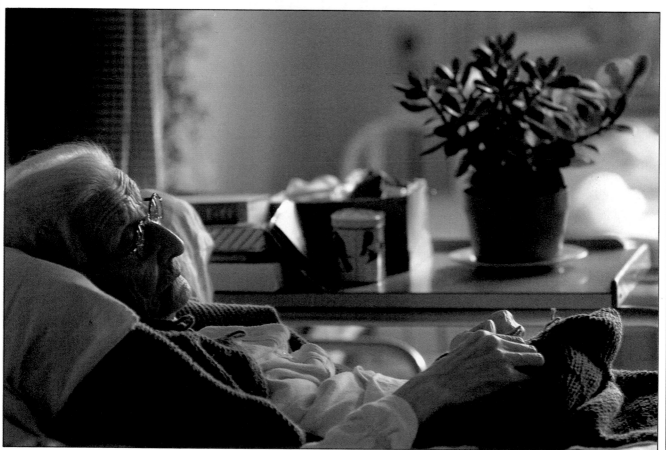

An aging woman lies motionless
in a geriatric home. A telephoto lens
enabled the photographer to remain at a
discreet distance from his subject and
to include the bedside table with its pot
plant, suggesting the woman's attempt
to make her environment more personal.

The committed camera

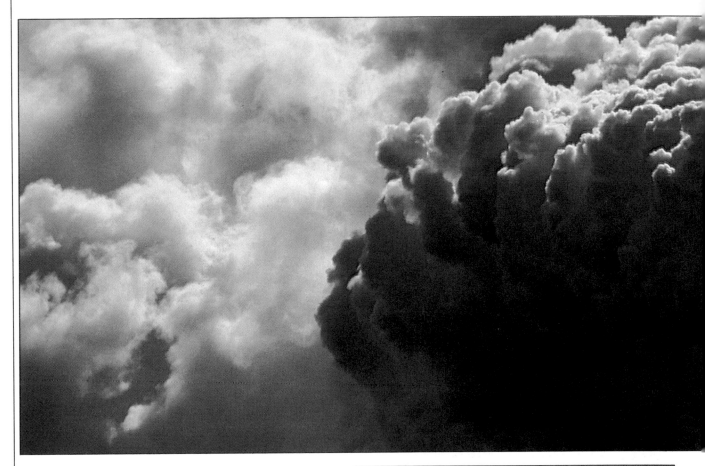

If you want to use photography to influence public opinion, concentrate on getting your message across in a single, powerful picture that can be taken in and understood in a single glance. For example, the photograph above would make a fine image for a campaign against atmospheric pollution because it forcibly concentrates the eye on the problem in its most visible form.

An objective approach that tries to show both sides of the story will inevitably dilute a picture's message. In this kind of photography you must make your own opinions clear and try to generate as much emotional energy from your subject as you can without distorting the facts. The pictures of animals at near and center right show how persuasive photographers can be when they adopt this no-holds-barred approach.

Of course, not all issues are as clear-cut and visually striking as those involving animal welfare. Sometimes the arguments that your photographs illustrate are subtle and abstract, and you may have to rely on symbols to make the point, as in the picture of demonstrators at a nuclear arms protest at far right.

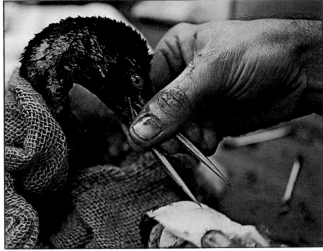

An oil-soaked bird gets a wash after a coastal oil spill. This close-up image of the effects on wildlife of such a disaster dramatizes the conservation problem far more effectively than would a picture of a floating oil slick.

Twin stacks belch smoke, and
the narrow angle of view of a 300 mm
lens fills the frame with thick clouds.
The resulting picture suggests, as the
photographer intended, that factory
pollution blocks out the sky and sun.

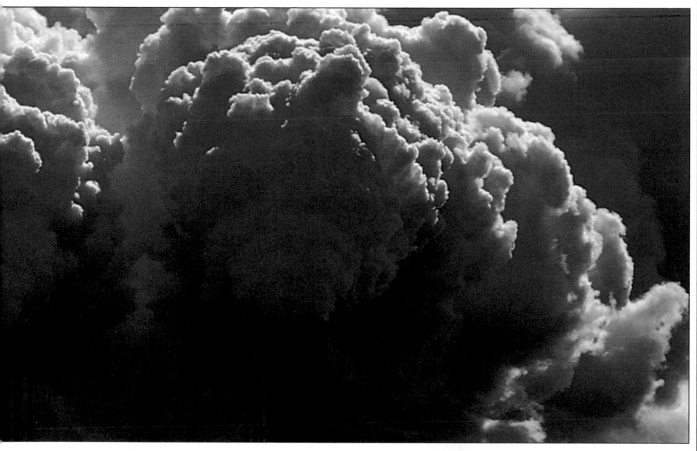

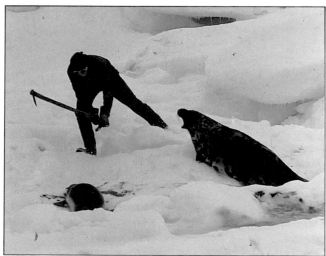

A northern hunter clubs a seal
pup to death – while the mother barks
a futile protest. A high viewpoint shows
man and seals as simple shapes against
the ice in a stark image that sticks
in the viewer's mind.

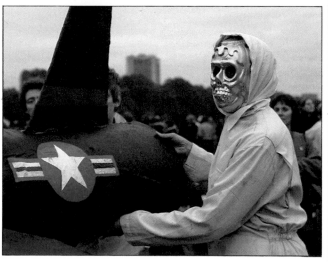

An anti-nuclear arms protester,
dressed as Death, carries a mock missile
through the streets. The photographer
singled out this chilling figure in an
effort to make sense of a crowded and
visually confusing demonstration.

Assembling and editing a story

For successful documentary photography, you need to take plenty of pictures and devote time to building them into a balanced, coherent picture essay. Thoughtful, methodical editing will make the most of your subject, and is essential if you have any intention of selling your work.

Bear in mind that if you intend to submit color pictures to a magazine, transparencies are usually preferred to prints. Begin by sorting the strongest images into piles and discarding the weaker ones. The next step is to divide your slides into categories such as overall scenes, more detailed views, individual portraits and so on. To compile the story here

on the annual motorcycle races at Daytona Beach, Florida, the photographer first sorted his slides into three groups, as shown below. He then chose the best pictures in each category to create the lively, varied record shown at right.

Variety is the key, whether you are aiming for a single-page story or a big photo-feature that might cover several pages. Try to contrast descriptive pictures with a few that have real impact, and include at least one image to convey the atmosphere of the occasion. Remember too that a magazine will probably want to juxtapose vertical and horizontal pictures, so take some in each format.

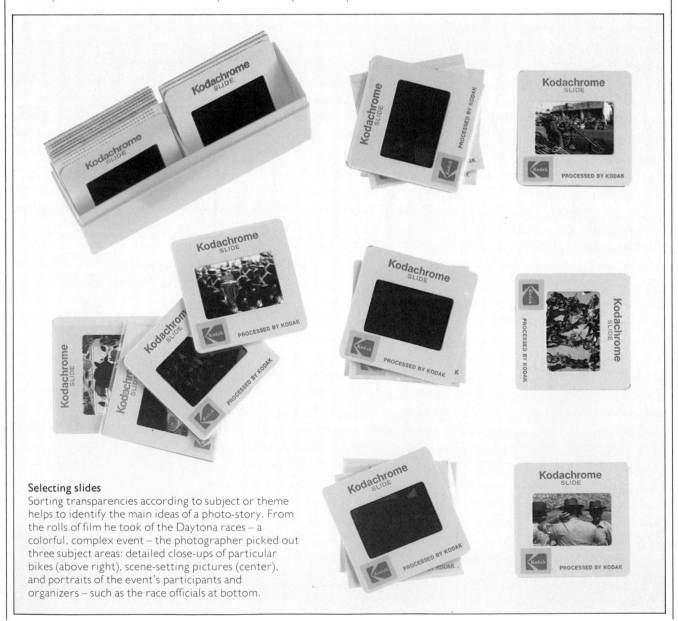

Selecting slides
Sorting transparencies according to subject or theme helps to identify the main ideas of a photo-story. From the rolls of film he took of the Daytona races – a colorful, complex event – the photographer picked out three subject areas: detailed close-ups of particular bikes (above right), scene-setting pictures (center), and portraits of the event's participants and organizers – such as the race officials at bottom.

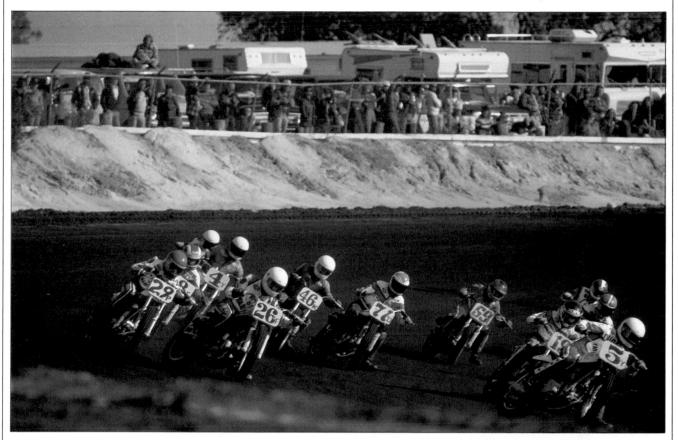

Powerful bikes tear around a cinder track circuit at Daytona Beach during the 100 mile race that began the week's activities. This strong scene-setting picture contrasts the mood of onlookers with the tension of the track.

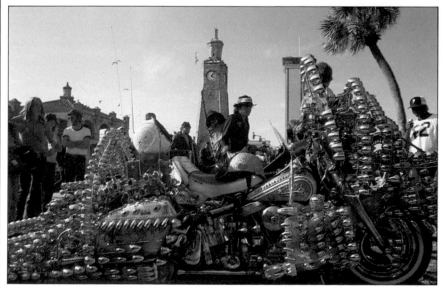

A Harley Davidson festooned with lights draws admiring and curious glances on a Daytona boardwalk. The photographer used a 28mm lens to give prominence to this gaudy feature of the races.

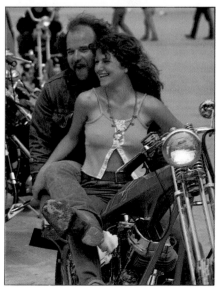

A biker and his companion meet with others on the beach. This sympathetic portrait, taken with a 135mm lens, shows that Daytona is a social event for all kinds of bike lovers.

The news story/1

The picture story on the following four pages was taken by photographer Susan Meiselas at the opening of the Vietnam Veterans' Memorial in Washington D.C. in October 1982. The series as a whole shows how a single photographer can tell a news story in pictures so powerful and varied that they can almost stand alone without words.

The memorial is a polished wall of black granite, 500 feet long and 10 feet high, and inscribed with 57,939 names of those Americans who died in the war. Meiselas photographed the wall thronged by friends and relatives (below), and – in a more formal head-on view – with a lone ceremonial guard on duty (overleaf). Other photographs help to create a more complete picture that begins to suggest the nation's ambivalent feelings about the war itself. The variety of visitors and their many moods, the contrast between those in crisp uniforms and those in jeans and beards, grieving parents, a disabled veteran and the demonstrators overleaf - all of these images combine in a rich portrayal of a day filled with complex and conflicting emotions.

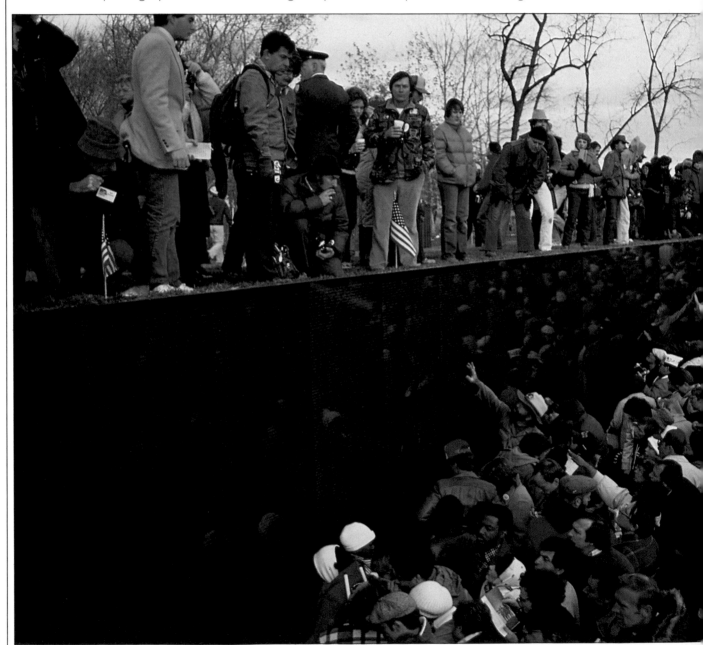

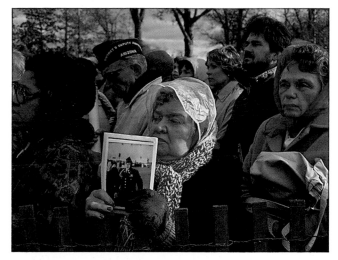

A bereaved mother (left) holds up a photograph of her dead son. A normal 50mm lens captured the close-up.

Crowds (below) reach out to touch the names of their kin. For this broad view of the enormous throng, the photographer used a 28mm wide-angle lens.

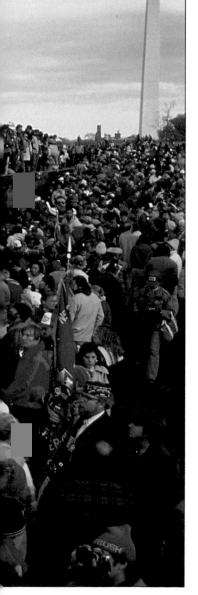

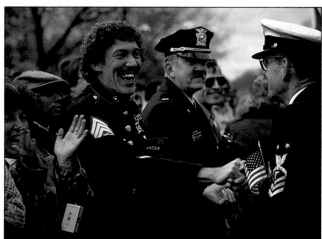

Reunited veterans (left) greet one another with a whoop. A fast shutter speed of 1/500 caught the moment of recognition.

An ex-combatant (below) waves to well-wishers in the crowds as the parade moves down Constitution Avenue. Mingling with the marchers, the photographer used a 28mm wide-angle lens to avoid the need for careful framing or focusing.

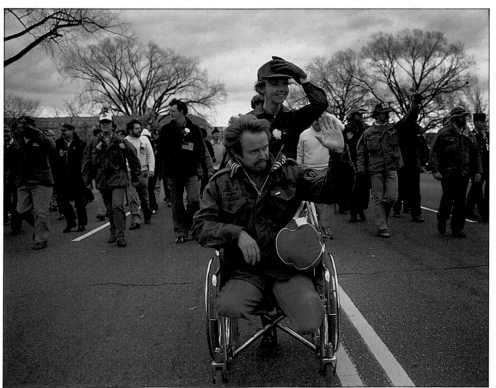

The news story/2

A standard-bearer (below) *posts ceremonial guard against the engraved expanse of the granite wall. The photographer also included the miniature flags left by visitors and a pair of boots standing as a poignant personal memorial.*

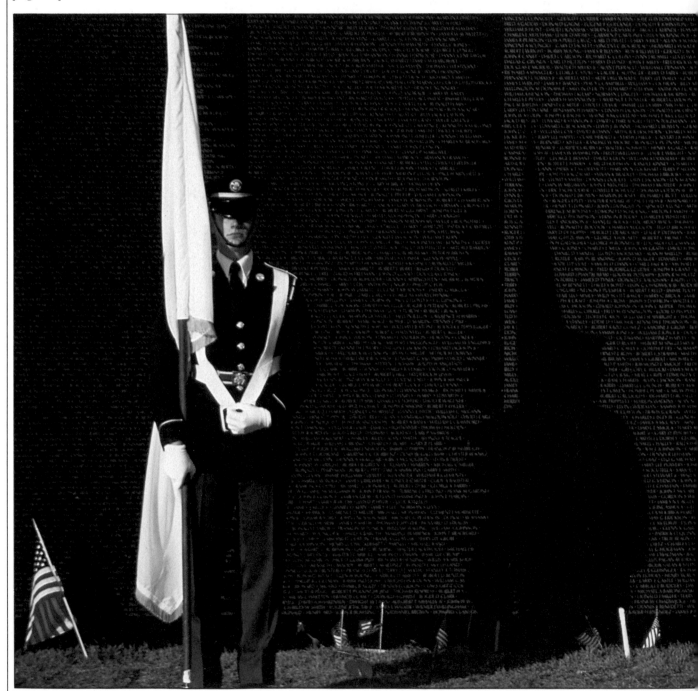

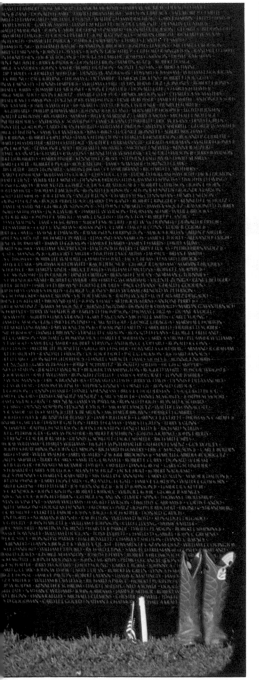

Anti-war veterans
(below) add protest to the
emotions expressed at the
parade, in a view intended
to remind us of the continuing
controversy surrounding both
the war and its memorial.

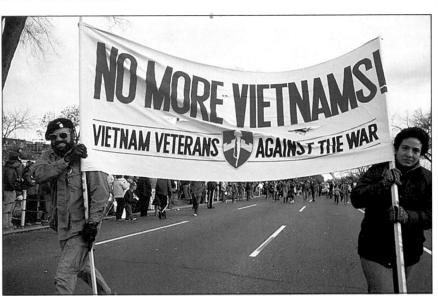

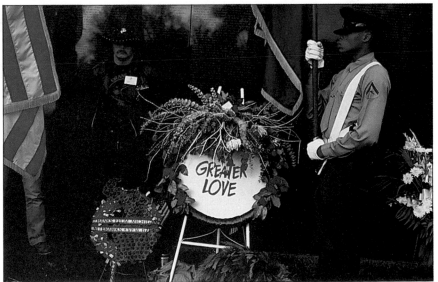

Another sentry *(above)*
is surrounded by veterans
and the personal mementoes of
mourners – a picture that
expresses the mix of formal
pomp and unrestrained emotion
characterizing the event.

The photo-essay/1

To make a comprehensive record of a subject that has broad, general interest rather than a specific, news-orientated one, you may need to take pictures systematically over a long period. Patrick Ward, the photographer whose pictures appear here and on the following three pages, has been doing just that for several years. His home is close to London's Hyde Park, and he takes photographs that document its changing moods as Londoners and visitors ebb and flow from season to season. A single visit to the park might have captured traditional aspects such as the soapbox orator or the parading guardsmen on the opposite page. But the character vignettes and tricks of light that give the whole portfolio its visual interest could come only from exploring and returning frequently to a familiar theme.

Recording things as you find them need not mean taking only descriptive pictures that read clearly. The three views here all gain atmosphere from strong backlighting. For example, in the view below the photographer took a meter reading from the highlight of the lake, so that the relatively under-exposed parkland suggests a landscape capable of disclosing the unexpected.

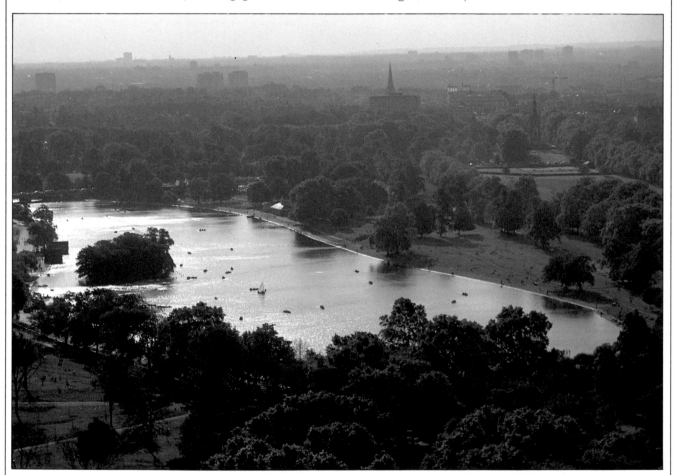

A general view of Hyde Park sets the scene for the photographs that follow. A tall building overlooking the park provided a high-angle view, and the photographer used an 85 mm lens to close in on the lake.

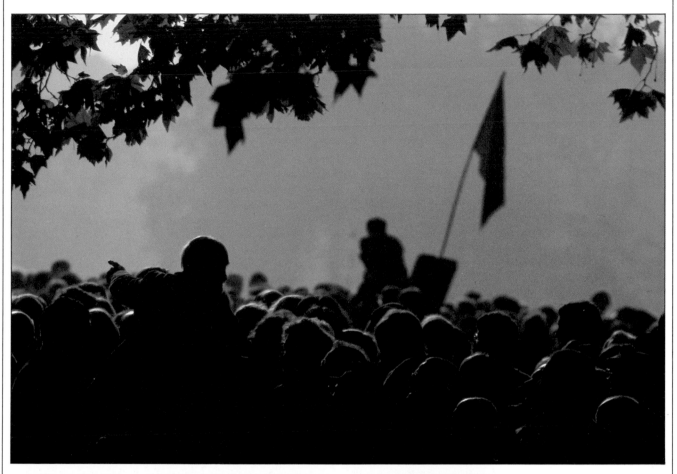

Soapbox speakers are a prominent attraction in one corner of the park. Pointing the camera toward the late afternoon light subordinated individual details and vividly evoked the atmosphere of the crowds and heated rhetoric.

Helmet plumes are backlit in the sun as guardsmen enact a time-honored ritual. To compress the ranks of advancing riders, the photographer chose a distant viewpoint and took the picture with a 400mm lens.

The photo-essay/2

Five lean whippets and their resting owner form a contrasting but well composed group on a sunny slope. The photographer remained unobserved by standing well back with a 200mm lens.

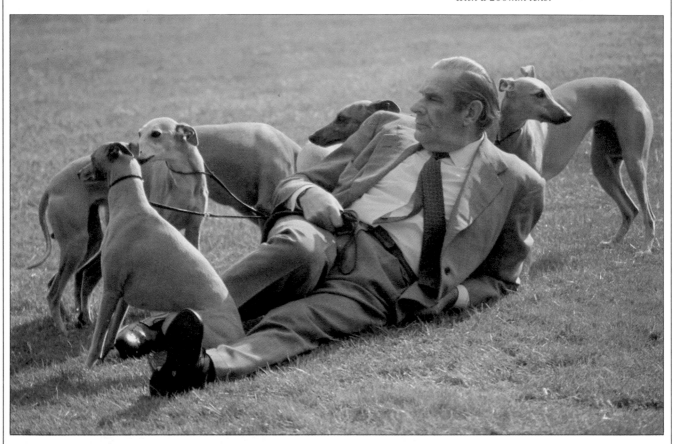

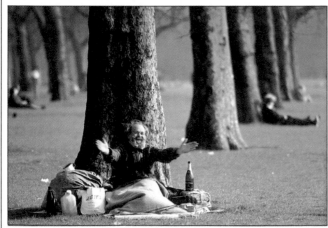

A happy hobo greets the world with outstretched arms. Stopping down a 135mm lens to f/16 added a soft but definite view of the tree-studded surroundings that identify the tramp's resting place.

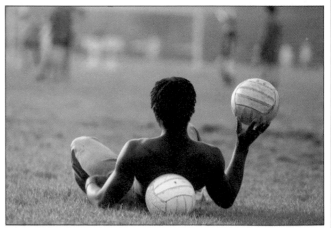

Waiting and watching, a soccer player stretches out on the sidelines. The picture, taken with a 200mm lens, introduces the park's recreational function in an oblique way, avoiding a clichéd sports picture.

A gilt frame and its seated occupant add a surreal note in an unposed picture taken during the arrangement of an art exhibition. Opening up one extra stop countered the strong backlighting.

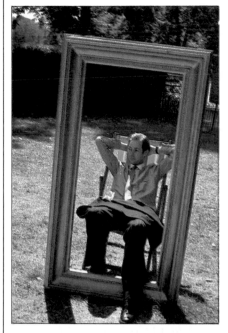

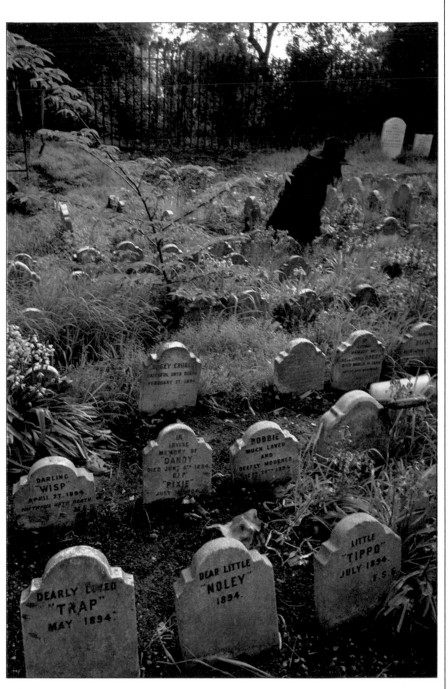

Fallen leaves and soft dappled sunlight convey the autumn season. By composing the picture around an early-morning jogger, the photographer adds energy to what would otherwise have been a static scene.

A cemetery for pets is tucked away in a corner of the park. A wide-angle lens gave a general impression of the scene, yet provided enough depth of field to keep in focus the sentimental inscriptions on the Victorian tombstones.

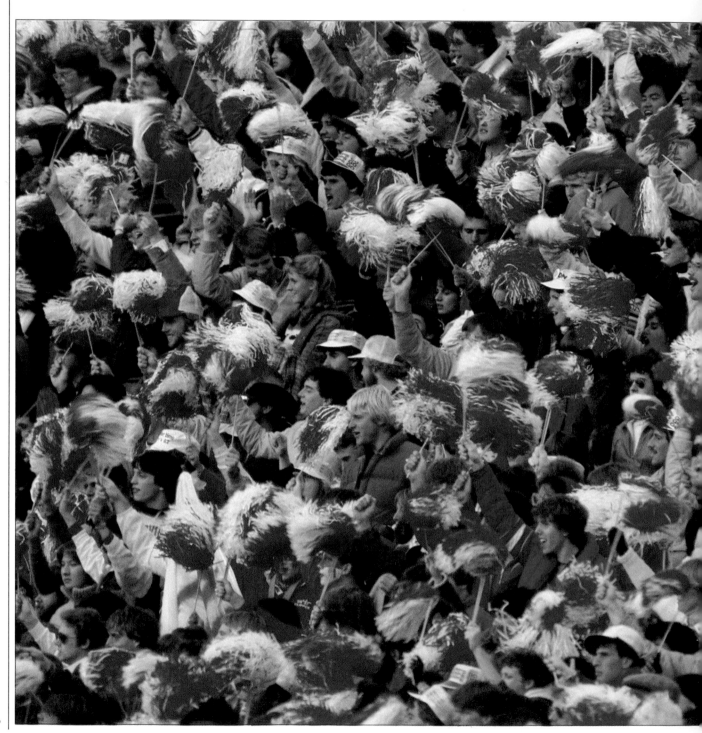

THE SPECIAL EVENT

Great public occasions are great photographic occasions too. Often, there will be dozens of professionals with specialized equipment taking pictures of the proceedings from their privileged standpoints. Yet your own photographs can compare with theirs if you are willing to put time and effort into improving your picture-taking chances.

Thorough research and planning of the event and location, and being ready with the right lens and film, will almost always pay off. Even if you do not have access to the best pictures of the main personalities, as the professionals do, you can turn a mere glimpse to your advantage by having your camera set to exploit the moment. Timing, an eye for detail and a feeling for the atmosphere of a popular occasion – the color and excitement of the crowds as well as the spectacle itself – are the factors that produce memorable images. And with imagination, you can find a fresh approach to the most familiar subject, as in the image at left of spectators at a baseball game, captured with a powerful long-focus lens to produce a vivid pattern of red and white.

Cheering supporters wave
*their pom-poms excitedly at a college
baseball game. A 400mm lens
compressed the crowd to convey
the charged atmosphere of the occasion
and strengthen the colorful pattern.*

Plan ahead

To photograph an organized event comprehensively, you need to prepare thoroughly in advance. The picture essay here shows just how much can be achieved by good planning, and its lessons will apply to many events closer to home.

The Venice Vogalonga is an informal Italian regatta that takes place every May. It is very much a local affair, organized by the Venetian boatmen for the Venetians themselves rather than for visitors to the city. The photographer wanted to convey not only the scale of the occasion and the picturesque setting, but also the lighthearted, popular character of the event. Having found out when and where the boats would start and the route they would follow (diagrammed below), he carried out a reconnaissance to locate the best standpoints for different pictures of the event.

A belltower on the island of San Giorgio Maggiore provided an ideal high-angle viewpoint for the start of the race (right). But on-the-spot research indicated that the liveliest action would take place at the opposite end of the city, in the Cannaregio area, where most of the boatmen live. To take in both aspects, timing was crucial. The photographer calculated that there would just be time to photograph the beginning of the race, take a boat across the Giudecca Canal to the main island, and then run through the city to a camera position on the Cannaregio Canal before the first boats arrived.

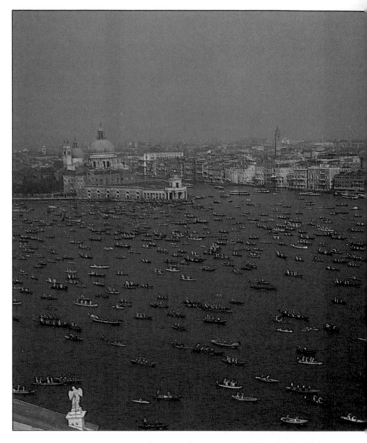

Cannaregio Canal

Grand Canal

Guidecca Canal

S. Giorgio Maggiore

On the map of Venice above, blue arrows mark the route of the Vogalonga boats with the blue dot marking the starting and finishing point. A red line shows the photographer's route.

Spectators view the progress of friends and relatives competing in the boat race from their apartment windows overlooking the Cannaregio canal. The decorative facade strongly establishes the Venetian setting.

Hundreds of boats dot the lagoon leading into the Grand Canal. A position in a belltower on San Giorgio Maggiore gave the photographer this splendid panoramic view with a 35mm lens of the beginning of the Venice Vogalonga.

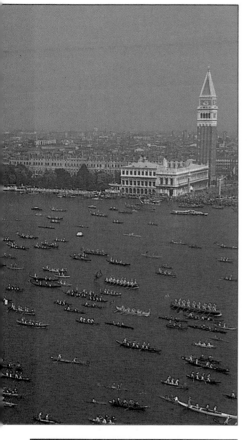

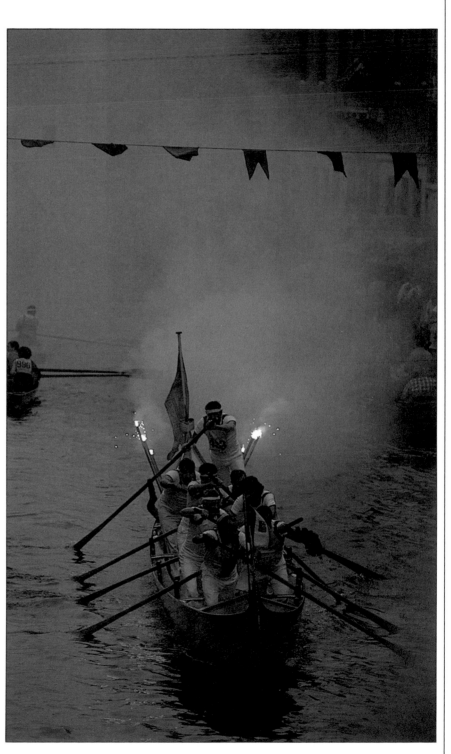

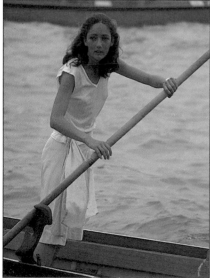

A lady gondolier, sporting her chosen colors, sculls gently along with a watchful eye out for other craft. The image conveys the open informality of the race: any Venetian can take part.

An eight-crew boat, its lighted flares spluttering in a drizzle, speeds down the Cannaregio Canal on the homeward run. The flamboyant craft and its wake of smoke made an atmospheric closing image.

The broad view

When you are photographing any special event, you will probably want at least one picture that gives an impression of how big an occasion it is. In providing a sense of scale, the choice of camera angle is crucial, and a wide-angle lens often helps to obtain scope. A conventional, spectator's view was just right for the photograph of the bullring on the facing page, but in less predictable situations you may have to spend some time in advance of the event looking for the perfect vantage point. Usually an elevated position is best. For the graduation ceremony at right the photographer posted himself at a window, having spotted the potential for a graphic picture. The high viewpoint with a 28mm wide-angle lens enabled him to exclude the horizon, giving the effect of an infi-

nitely extended procession.

If access to the ideal spot is difficult, you may have to arrive early and stay there for the duration of the performance. Decide beforehand whether it is worth sacrificing your freedom of movement for the sake of just one or two broad views.

Aerial photography offers exciting possibilities if you get the opportunity to fly over a location at the right time. The photograph at bottom — a crowded beach scene on Labor Day, taken from a helicopter — illustrates how pattern and color tend to become dominant elements from the air. Alternatively, try using a telephoto lens from high ground to flatten perspective in a crowd scene and give an exaggerated sense of people packed together.

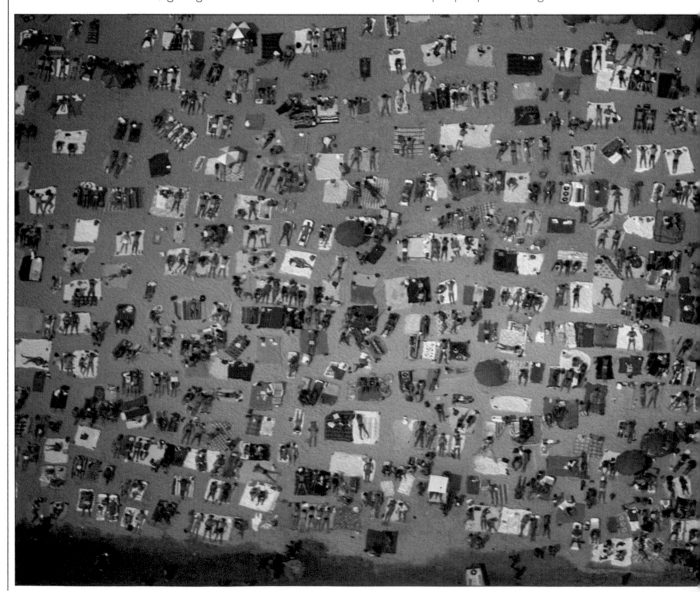

Graduates of the University of Virginia, Charlottesville, walk solemnly through the portico of the Rotunda. A high camera angle and a 28mm wide-angle lens produced a powerful compositon held together by the symmetrically diverging columns.

Beach crowds near Atlantic City on Labor Day resemble a mosaic or an abstract painting when photographed from a helicopter directly above. The tiny sunbathing bodies on beach towels, and the green rented umbrellas, are recurrent motifs that give unity to the composition.

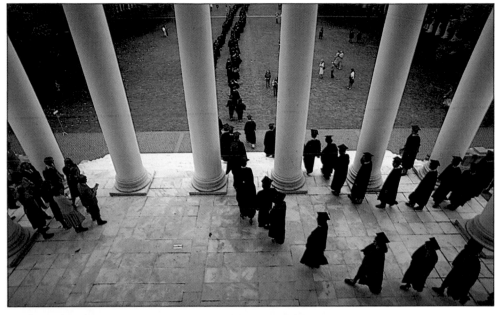

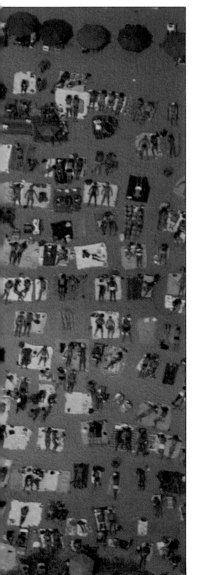

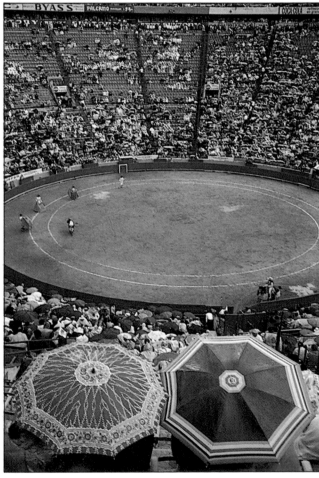

A bullfight in Mexico City continues despite the rain. When the umbrellas were opened, the photographer was fascinated by the addition of new shapes to a scene already strongly geometrical. A 35mm wide-angle lens allowed him to fill the foreground with two umbrellas whose colors harmonize perfectly with the rest of the scene.

The telling detail

At any public event, there will be intervals when nothing very much is happening. These lulls in the action offer the chance to study the smaller, less obvious elements in a scene. Well-observed details can help to fill out your coverage of an occasion and to make your record more personal.

Of course the sort of subjects you find for detail pictures will depend on the situation as well as on your own interests. At a parade or pageant, you might pick out a splendid uniform or an exotic costume as a feature. In the picture at right, the shawl makes an attractive composition that also reveals an aspect of traditional craft. Sometimes a detail in the scene can serve as a symbol for the event, as does the Olympic flame shown on the opposite page.

Carrying a choice of lenses enables you to vary your compositions and reach detailed subjects wherever they are. A telephoto or zoom lens will pull small, distant elements into prominence. Alternatively, with a wide-angle lens you can emphasize a chosen detail close to the camera without losing the wider context. The unusual image below, taken from the edge of the stage, would not have been possible with a normal lens.

The intricate design of a lace shawl is a typical feature of costumes worn by French girls at a festival in Provence. The photographer moved in close with a normal lens and framed the subject to emphasize the strong V-shaped lines against the dark background of the dress.

Flames playing in the firebowl
at the 1980 Olympic Games in Moscow
symbolize the event and give a focal point
to the out-of-focus crowds behind.
The photographer used a 135 mm lens and
strengthened the detail by centering
the subject in the frame.

Sturdy legs in yellow stockings
(left) provide an original and colorful
image of a historical pageant at Beaune,
France. A 28 mm lens enabled the
photographer to make the most of his low,
close viewpoint.

The decisive moment

Capturing the moment that sums up what an occasion is all about demands a combination of photographic skills. You need to anticipate the action, judge the best picture angle and then choose just the right moment to press the shutter release.

Successful pictures of this type may look as if they are unique, and hence the result of split-second reactions – or even sheer luck. But this is rarely true. The fact is that decisive moments usually occur more than once. Unfolding events have an inherent rhythm, often building to a peak several times, and if you are alert to this, you can see what works best photographically and then wait for the moment to recur. The photograph of Billy Graham, below, is an

example: the gesture was repeated many times, although the image seems to express a unique moment. Once you are accustomed to observing and anticipating high points in this way, you will find that you have time to compose your pictures, focus and set exposure in advance so that you are able to press the shutter release a fraction of a second before the anticipated peak.

In each of the photographs here, the lighting conditions precluded hurried picture-taking at very fast shutter speeds. Yet the lighting and the timing give such dramatic intensity to the images that each photograph seems to snatch the one special moment that epitomizes the occasion.

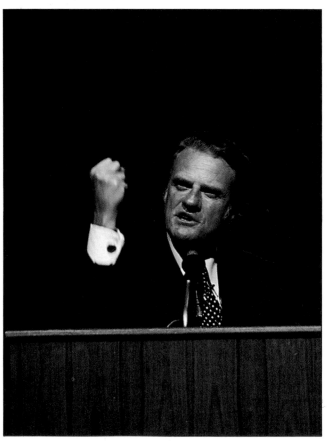

Preacher Billy Graham raises a clenched fist to drive home a point in his sermon. The photographer used 1/60 at f/4, exposing for the midtone of the podium to retain the strong contrast that points up the subject's dynamic style of delivery.

Australian acrobats form a pyramid at London's Round House theater. Noting that the performers periodically made a formation, the photographer set his camera at 1/60, f/2.8 and waited for them to build up to the dramatic climax in their act.

Dense smoke (right) *fills the night sky behind a crowded square in Catania, Sicily, during a religious festival. A setting of 1/60 at f/4 on ISO 400 film captured the flaring bonfire at a moment that sums up the intense mood of the occasion.*

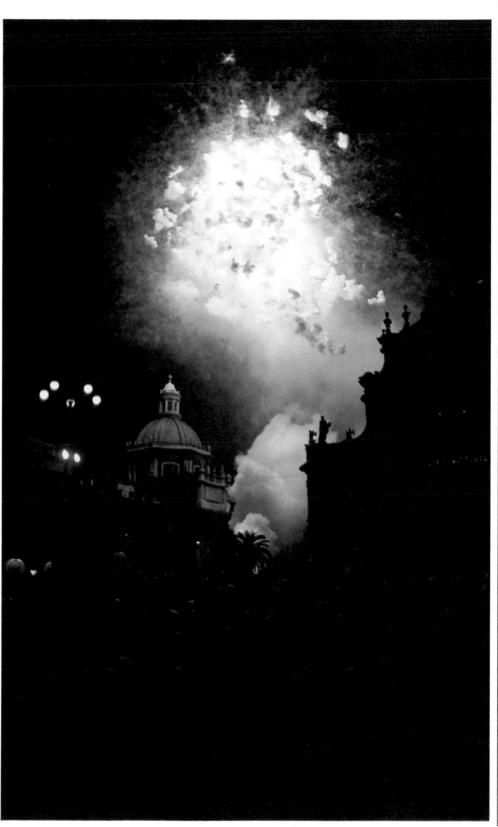

Capturing atmosphere

Capturing faithfully the atmosphere of a special occasion is much more difficult than simply making a straightforward visual record of what is going on. This is because the sensation of being a participant or spectator comes partly from sounds and smells or from the press of a crowd – none of which you can capture directly with a camera.

To suggest these sensations, you must rely on visual associations. For example, in the pictures immediately below and at right, bright colors help to imply energy, vitality and excitement, and the photograph at the bottom of the opposite page uses soft focus to suggest the glare and sparkle of a parade in brilliant sunshine.

At an event infused with carefree enjoyment, you seldom have to worry that your camera will have an inhibiting effect. In the scene below, a 3-D film show, the audience's hilarity was such that no-one even noticed the photographer as he turned round to take the picture.

At a concert (right) a solo performer gestures in the beam of a spotlight. The visual syncopation of the outstretched arm, the shadow and the brilliant colors combine to re-create the dynamism of the music.

A neon-ribbed tunnel delights young visitors at the opening of the Epcot Center, the futuristic community at Walt Disney World in Florida. To intensify the colored light, the photographer took a reading from the tubes themselves.

Watching a 3-D film (below), an audience laughs uncontrollably at a moment of high comedy. By the light from a direct flash, their faces seem to spring forward from the picture in a way that echoes the impact of the film they are seeing.

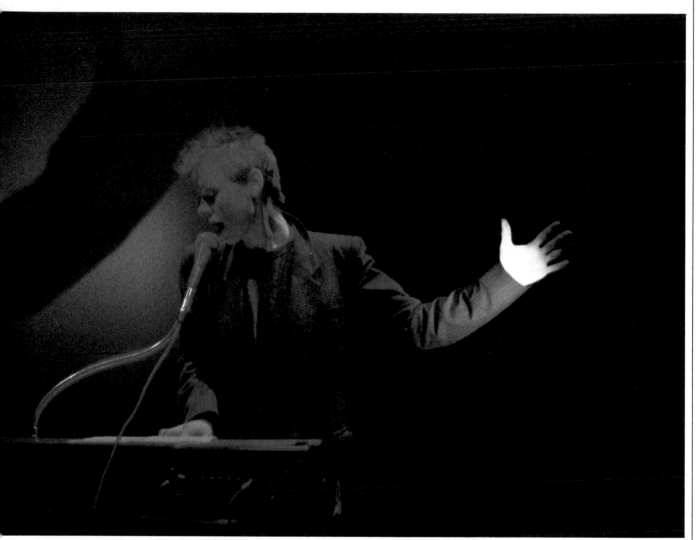

Young cheerleaders
(left) seem to glow in the spring light – an effect that the photographer created by removing the lens from his camera and breathing on the rear glass surface. When he replaced the lens and took the picture, the condensation spread out the bright highlights.

Faces in the crowd

Turning your camera on the spectators can provide pictures as lively and fascinating as those of the event itself. Make a habit of scanning the crowds every so often, looking out for interesting faces. People cheering on their favorite team, or anxious about the outcome of a feat of daring, or simply waiting for the action to begin, make marvelous subjects for candid photography.

If you are some distance away – perhaps facing a crowd on the other side of a street or stadium – a telephoto lens is very useful. The shallow depth of field and narrow view enable you to pick an individual out of a group or mass of people and to throw surrounding or background details out of focus, as in the two pictures on this page. A long lens is also handy because the compressed perspective can encompass a whole range of facial expressions, as at bottom right, where reactions vary from mild involvement to intense emotion.

If you are in the midst of a crowd, take advantage of your position by looking for interesting subjects close to you, but remember that you will probably have to aim and focus much more swiftly. A wide-angle lens is best for this purpose and lets you frame to include some elements of the surroundings, as in the carnival picture at right.

A flower girl seems disgruntled by a long wait in line during a Welsh music festival. The photographer noticed her frown and used the shallow depth of field of a long lens to pick out the face in sharp focus.

The flamboyant attire of a rotund photographer at the 1980 Superbowl in Pasadena provides a lively, colorful image. A 105 mm lens isolated the figure and left the busy background unfocused.

A Brazilian woman's vivacious grin seems to draw the viewer right into a carnival scene. The photographer spotted her when he was moving backward through the crowd, and used a 35mm lens to include the glittering hats behind.

The mixed reactions of spectators at a horserace in Calcutta, India (below), produced a fascinating study of human nature. The photographer closed in with a 200mm lens to compress the rows of excited faces.

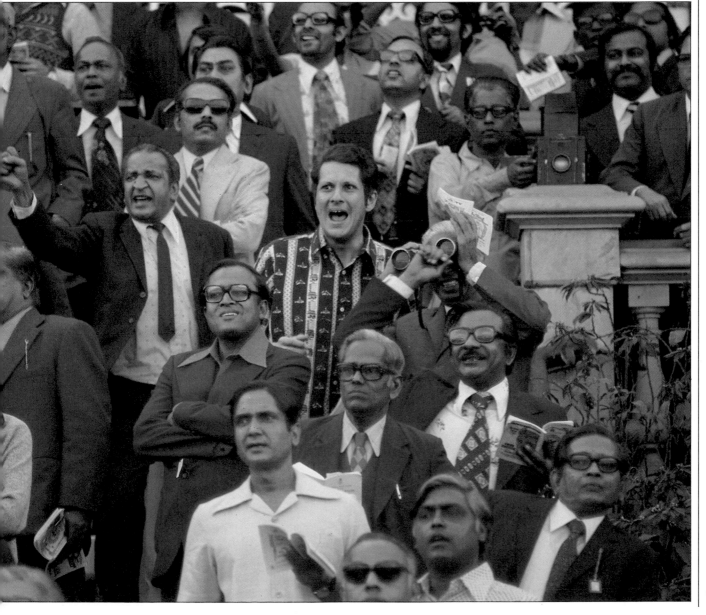

Catching the unexpected

However carefully you anticipate and plan your photographic coverage of an event, there will always be incidents that you could not possibly have predicted. Moments of visual irony or explosive emotion, such as the confrontation shown below, will add a human touch to your documentary photography, if you are quick enough to record them.

The knack of capturing such unexpected happenings does not depend on some kind of sixth sense. But it does require, in addition to astute observation, the ability to react with almost instinctive speed to changing situations.

This is a skill that you can develop with practice, first by accelerating the mechanical aspects of picture-taking, such as setting focus and exposure. Without any film in the camera, simply time how long it takes you to raise the camera to your eye, set the controls, and release the shutter. Then try to halve this time – and halve it yet again.

Of course the real test – and the best practice of all – is actually taking pictures speedily. This is the only tangible way to monitor your ability to compose pictures in a hurry. By looking at the results, you can learn a lot about the distances and apertures at which quick focusing is feasible, and about the level of skill you have reached in framing the subject correctly instead of just pointing the camera in the general direction of the action.

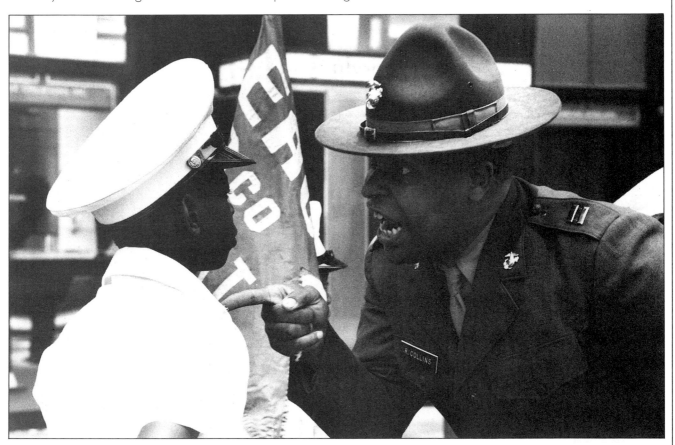

A race official (left) remains seated as an injured runner writhes at his feet. Knowing that race rules forbade the official to leave his post, the photographer swiftly trained his 400 mm lens not on the runner receiving medical attention but on the predicament of the official looking on.

An angry instructor berates his bewildered charge for letting his attention wander during a parade. The photographer glimpsed the start of the incident through the crowd and set the controls on his camera as he moved in closer to isolate the scene with an 80 mm lens.

Glossary

Aperture

The opening in a lens that admits light. Except in very simple cameras, the aperture can be varied in size by a diaphragm, which controls how much light passes through the lens and onto the film.

ASA see FILM SPEED

Automatic exposure

A system that automatically sets the correct exposure by linking a camera's exposure meter with the shutter or aperture, or both. There are three main types: aperture priority (the most popular), when the photographer sets the aperture and the camera selects the appropriate speed; shutter priority, when the photographer chooses the speed and the camera sets the correct aperture; and programmed, when the camera sets both aperture and shutter speed. Aperture priority is advantageous when you want to control depth of field; shutter priority comes into its own particularly in action photography; and programmed exposure can be useful when the photographer has to react quickly.

Automatic focusing

A camera system that automatically brings the lens into sharp focus on the subject. The most common method of automatic focusing works on the same principle as the rangefinder, using two mirrors within the camera to produce two views of the same scene. Other systems use ultrasonic waves or a beam of infrared light. Automatic focusing is used mainly on compact cameras.

Compact camera

A simple 35mm camera that has a non-interchangeable lens and is intended primarily for taking snapshots.

Depth of field

The zone of acceptable sharpness in a picture, extending in front of and behind the plane of the subject that is most precisely focused by the lens. You can control or exploit depth of field by varying three factors: the size of the aperture, the distance of the camera from the subject, and the focal length of the lens.

Diaphragm

The part of the camera that governs the size of the aperture. The most common type is the iris diaphragm – a system of overlapping metal blades forming a roughly circular opening that is variable in size and similar in principle to the iris of the human eye.

Exposure

The total amount of light allowed to pass through a lens to the film, as controlled by both aperture size and shutter speed. The exposure selected must be tailored to the film's sensitivity to light, indicated by the film speed rating. Hence, over-exposure means that too much light has created a slide or print that is too pale. Underexposure means that too little light has resulted in a dark image.

Fast lens

A lens of wide maximum aperture, relative to its focal length, allowing maximum light into the camera in minimum time. The speed of a lens – its relative ability to take in light – is an important measure of its optical efficiency: fast lenses are harder to design and manufacture than slow lenses, and consequently cost more.

Film speed

A film's sensitivity to light, rated numerically so that it can be matched to the camera's exposure controls. The two most commonly used scales, ASA (American Standards Association) and DIN (Deutsche Industrie Norm), are now superseded by the system known as ISO (International Standards Organization). ASA 100 (21°DIN) is expressed as ISO 100/21° or simply ISO 100. A high rating denotes a fast film, one that is highly sensitive to light.

Flash

A brief but intense burst of artificial light, used in photography as a supplement or alternative to any existing light in a scene. Batteries supply the power to most flash units. Some small cameras have built-in flash, but most handheld cameras have a slot on top that takes a flash unit.

Lens

An optical device made of glass or other transparent material that forms images by bending and focusing rays of light.

Long-focus lens

A lens that concentrates on only a small part of the subject, making distant objects appear closer and magnified. Most long-focus lenses are of the type known as telephoto lenses. These have an optical construction that results in their being physically shorter than their focal length, and consequently easier to handle than non-telephoto long-focus lenses. Almost all long-focus lenses are now telephoto lenses and the two terms tend to be used interchangeably.

Motordrive

A battery-operated device that attaches to a camera and automatically advances the film and resets the shutter after an exposure has been made. Some motordrives can advance the film at speeds of up to five frames per second; these are particularly useful for sports and other action photography.

Normal lens

A lens producing an image that is close to the way the eye sees the world in terms of scale, angle of view and perspective. For most SLRs the normal lens has a focal length of about 50mm.

Prefocusing

The technique of setting the camera's focus in anticipation of the subject's movements as an aid to quick picture-taking. Usually the focus is set on a motionless feature toward which the subject is moving.

Rangefinder

A device for measuring distance, used as a means of focusing on many cameras. The rangefinder works by displaying, from slightly different viewpoints, two images that must be superimposed or correctly aligned to give the exact focusing distance. A "coupled rangefinder" is one linked to the lens in such a way that when the images in the viewfinder coincide, the lens is automatically focused to the correct distance.

Reflex camera

A camera employing a mirror in the viewing system to reflect the image onto a viewing screen. The most popular type is the single lens reflex (SLR), which reflects the light from the same lens that is used to take the picture. The twin lens reflex (TLR) has an additional lens for viewing and focusing.

Shutter

The camera mechanism that controls the duration of the exposure.

Telephoto lens see LONG-FOCUS LENS

Wide-angle lens

A lens with a short focal length, which gives a wide view of the subject within the frame.

Zoom lens

A lens of variable focal length. For example, in an 80-200mm zoom lens, the focal length can be changed anywhere between the lower limit of 80mm and the upper limit of 200mm. This affects the scale of the image on which the lens is focused without throwing the image out of focus. Because they save you time by offering a variety of focal lengths within one body, zoom lenses are particularly useful in action and candid photography.

Index

Page numbers in *italics* refer to the illustrations and their captions.

Acknowledgments

Picture Credits

Abbreviations used are: t top; c center; b bottom; l left; r right.
Other abbreviations: IB for Image Bank and SGA for Susan Griggs Agency. All Magnum pictures are from The John Hillelson Agency.

Cover Tom Zimberoff/Sygma

Title Ken Griffiths. **7** Ernst Haas/Magnum. **8** Barry Lewis/Network. **8-9** Thomas Ives/SGA. **9** Steve Benbow/Network. **10** Leonard Freed/ Magnum. **11** John Garrett. **12** Mike Goldwater/Network. **12-13** Alain Le Garsmeur/SGA. **14** Harry Gruyaert/Magnum. **15** Tor Eigeland/SGA. **16** P. Gleizes/Explorer. **18** John Garrett. **18-19** Ernst Haas/Magnum. **19** Brian Frechette. **20** Richard Laird/SGA. **21** t, b Steve Benbow/Network. **22** c Philip Barker/SGA. **23** David Maenza/IB. **24** t George Skirrin, b Paula Marie Elston. **25** tl Frank T. Wood, tr Jim Dennis, b Michael Freeman. **26** l Adam Woolfitt/SGA, r John Garrett. **27** t Ed Mullis/Aspect Picture Library, b Alain Choisnet/IB. **28** l Robin Laurance, r John Lewis Stage/IB. **29** Pete Turner/IB. **30** l Adam Woolfitt/SGA, tr Barry Lewis/ Network. **30-31** Bullaty/Lomeo/IB. **31** Adam Woolfitt/SGA. **32** tr, cr, br Barry Lewis/Network. **33** all John Benton-Harris. **34** l Barry Lewis/ Network, r Tom Nebbia/Aspect Picture Library. **35** t Adam Woolfitt/ SGA, b Robin Laurance. **36** Alex Webb/Magnum. **36-37** Burk Uzzle/ Magnum. **39** Barry Lewis/Network. **40** Robin Laurance. **40-41** Leonard Freed/Magnum. **41** Alex Webb/Magnum. **42** John Benton-Harris. **43** t Robin Laurance, b John Sims. **44** John Bulmer/SGA. **44-45** Elliot Erwitt/ Magnum. **45** Paul Fusco/Magnum. **46** Erich Hartmann/Magnum. **46-47** Homer Sykes. **47** t, b John Benton-Harris. **48-49** Susan Meiselas/ Magnum. **50** Tom Kasser/Gamma. **50-51** Frank Spooner Agency. **51** t Judah Passow/Network, b Gilles Canon/Gamma. **52** John Garrett, b Gilbert Uzan/Gamma. **53** Lawrence Fried/IB. **54** Barry Lewis/Network. **55** t Laurie Sparham/Network, b John Sturrock/Network. **56** t John Sugar/Black Star, b Gamma/Frank Spooner Agency. **57** Ernst Haas/ Magnum. **58 & 59** all John Garrett. **60** t Martine Franck/Magnum, b Barry Lewis/Network. **61** t Chris Steele-Perkins/Magnum, b Steve Benbow/ Network. **62** tl John Benton-Harris, tr, b John Garrett. **63** Homer Sykes. **64** t Bruno Barbey/Magnum, b Julian Calder. **65** Ted Streshinsky/IB. **66** Richard Dudley-Smith. **67** Geray Sweeney. **68** l Momatiuk Eastcott/ Woodfin Camp Associates, r Julian Calder. **69** Julian Calder. **70** t Robin Laurance, b Roger Malloch/Magnum. **70-71** Richard Kalver/Magnum. **72** Arnaud de Wildenberg/Gamma. **73** t Richard & Sally Greenhill, b Patrick Ward. **74** Paul Fusco/Magnum. **74-75** Marc St. Gil/IB. **75** l Frank Spooner Pictures, r Steve Benbow/Network. **77** all Patrick Ward. **78 & 79** all Susan Meiselas/Magnum. **80 & 81** all Susan Meiselas/Magnum. **82 & 83** all Patrick Ward. **84 & 85** all Patrick Ward. **86-87** Leo Mason. **88 & 89** all Adam Woolfitt/SGA. **90-91** Joseph F. Viesti/SGA. **91** t John Lewis Stage/IB, b Victor Engelbert/SGA. **92** t Dennis Stock/Magnum, b Gilles Peress/Magnum. **93** Leo Mason. **94** l John Garrett. **94-95** David Whyte. **95** Steve Benbow/Network. **96** t, b Rene Burri/Magnum. **96-97** Chris Davies/Network. **97** Andrew De Lory. **98** l Leo Mason, r Steve Benbow/Network. **98-99** MF. **99** Ian Berry/Magnum. **100** Leo Mason. **101** John Benson-Harris.

Additional commissioned photography by John Garrett, John Miller.

Acknowledgments Dixons Professional Camera Ltd., Keith Johnson Photographic, Leeds Camera Centre.

Artists Aziz Khan, Sandra Pond, Andrew Popkiewicz

Retouching Roy Flooks

Kodak, Ektachrome, Kodachrome and Kodacolor are trademarks

Time-Life Books Inc. offers a wide range of fine recordings, including a *Big Bands* series. For subscription information, call 1-800-621-7026, or write TIME-LIFE MUSIC, Time & Life Building, Chicago, Illinois 60611.

Notice: all readers should note that any production process mentioned in this publication, particularly involving chemicals and chemical processes, should be carried out strictly in accordance to the manufacturer's instructions.

Printed in U.S.A.